IMAGES
of America

GEORGETOWN

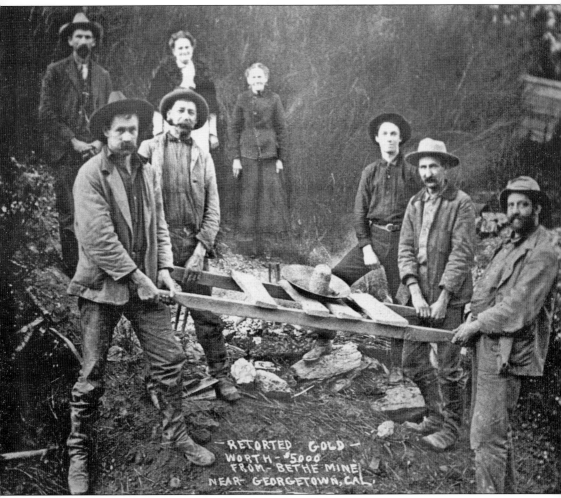

RETORTED GOLD —
WORTH — $5000
FROM — BETHE MINE
NEAR GEORGETOWN, CAL.

Beattie Mine shareholders and Beattie family members are pictured with the results of a cleanup of a sluice box after quicksilver has been burned off. The value of the gold left in the box is about $35,000. From left to right are (first row) Herman Barklage, Andrew Kenna, Billie Beattie, Chris Beattie, and Tom Morgan; (second row) unidentified, Annie Beattie, and Catherine Beattie. (Courtesy Joseph Flynn.)

ON THE COVER: According to early civic leader Tom Gibbs, election practices would have been considered quite clean for typical 19th-century elections, as Georgetown was one of the few mining camps whose vote count nearly corresponded to the voting population. No steamship lists, burial lists, or laundry customer lists showed up. Georgetown's motto was "Vote the Man," meaning a live person was required to show up at the polls and actually mark a ballot. Of course a boy was considered a man when he could stand up to a whiskey barrel, drink the shot all voters were allowed, and go in to mark his ballot. Voters' usefulness at the polls ended when consumed whiskey became a factor, the favored candidate was way ahead, or the whiskey barrel ran dry. Voters gathered on Georgetown's Main Street on November 4, 1890, for this photograph. (Courtesy California State Library.)

IMAGES
of America

GEORGETOWN

Sheryl Rambeau

ARCADIA
PUBLISHING

Published by Arcadia Publishing
Charleston SC, Chicago IL, Portsmouth NH, San Francisco CA

Printed in the United States of America

Library of Congress Control Number: 2010922854

For all general information contact Arcadia Publishing at:
Telephone 843-853-2070
Fax 843-853-0044
E-mail sales@arcadiapublishing.com
For customer service and orders:
Toll-Free 1-888-313-2665

Visit us on the Internet at www.arcadiapublishing.com

CONTENTS

ACKNOWLEDGMENTS

Many thanks to my longtime partners for collecting vintage photographs and compiling much of Georgetown history: Larry Anderson and Bonnie Wurm. Bonnie's skill, assistance, and support have been invaluable. Larry has long been a source of encouragement and advice. Thanks, guys! Unless otherwise noted, all images appear courtesy of the author.

INTRODUCTION

Discovery of raw gold in California's American River was an event that permanently altered West Coast landscape. As word of the January 24, 1848, gold discovery spread, would-be miners hastened to reach California—and gold. Early arrivals focused on Coloma Valley and the American River where "color" (slang for the term gold) had first been found. More enterprising miners moved uphill, expanding their search into contributing streams and intermittent waterways.

An ancient upheaval of land divided the American River, leaving the ridge down the middle ripe for gold exploration with the South Fork of the American River on one flank and the confluence of the North and Middle Forks of the American River on the other.

Diary entries place William Wood and George Brooks as the first recorded miners in Georgetown in March 1848. Wood and Brooks followed streambeds back to their sources, filled their pockets, and then moved on.

The most significant early find was made in 1848 by Oregonians William Hudson and his party who bypassed lower, crowded slopes and explored a likely looking gulch northeast of present-day Georgetown. It is estimated the Hudson party took over 300 pounds of gold per week from Hudson Gulch.

New Yorkers George Phipps and John Cody set out in 1849 seeking their own bonanzas. The exploring party split, half remaining with Cody to investigate Manhattan Creek, the rest traveling with Phipps to follow Empire Creek to the waterway's headwaters at the top of the ridge. Phipps established a base camp just above the headwaters. It was a convenient location, equidistant from the rivers on both sides. Others joined Phipps's camp, and a thriving community of gold seekers formed at "George's Town," expanding into a major supply center for the mushrooming gold fields surrounding it. George's Town became the largest and most centralized community of the area, lending the town's name to the entire geographical description, the Georgetown Divide.

That first settlement had the era's usual hotels, mercantiles, and saloons huddled east and west along the sides of the canyon. A dozen semipermanent structures of logs, shakes, and canvas appeared, families arrived, and a town was born.

This village completely burned in 1852. Local miners, storekeepers, gamblers, and residents were unanimous in a decision to rebuild. Three local men were designated to draw up reconstruction plans. A spot somewhat uphill and slightly south was chosen, and a new town site with a unique design began to spring up immediately. Towering sugar pines covered the site, but volunteers pitched in, and trees were promptly turned into logs. A sawmill worked day and night supplying lumber for the new community.

More families arrived, and churches and schools began to appear. Proper civilization reached Georgetown. Gold continued to drive the economy. Merchants moved into the logical link between Placerville, Auburn, and the area's multiple mining camps. Georgetown was a distributing point for supplies, mining equipment, and travel, gradually becoming a commercial hub. Stage lines connected with other towns, and all manner of services were available to meet the needs of those living there.

In spite of planners' good intentions, three devastating fires leveled the town within 20 years. The fire in 1869 was particularly tragic, as for the first time there were fire-related deaths. Business leaders took a hard look at the town's building standards, and several new fireproof brick buildings were interspersed among the usual frame-and-clapboard structures during reconstruction.

The population stabilized, and Georgetown continued to be the primary village on the Georgetown Divide even though the Gold Rush subsided and tapered off.

Gold claims evolved from solitary miners to partnerships or companies conducting mining operations. The Eureka and Alpine mines were reopened in the 1880s, fueling some development and expansion, until gold production failed to keep up with operating costs.

Lumbering became increasingly important, and Georgetown adjusted from a mining town to a lumbering community. Timber companies formed to take advantage of the huge tracts of timberland around Georgetown.

Another fire of epic proportions hit in 1897, destroying or damaging most of the town's business district. Much of the life of the town died in the ashes. Weary of starting over again and again, some of the populace simply moved away. Groundwater in mines had increasingly become a hindrance, hydraulic mining ceased, and local lumber companies were facing economic hardships of their own. Georgetown's economy began spiraling downward at the beginning of the 20th century from its flourishing Gold Rush beginnings.

A few economic bursts appeared. New Highland Gold and Copper Mining Company scooped up almost 1,000 acres of land in 1903, planning to expand and operate 19 old mines. Unfortunately, this ambitious undertaking did not succeed, passing quietly into oblivion.

Expectations were raised in 1916 when Beebe Mining Company opened the Eureka and Woodside mines. Several Georgia Slide Mines also reopened. Pino Grande Mill was operating at full capacity, employing over 400 men.

World War I halted the impetus. Gold mines in the vicinity closed as gold was declared a nonessential industry, failing to reopen post war. Georgetown was on the verge of fading completely into obscurity.

The Great Depression caused distress in the rest of the country, but actually brought prosperity to Georgetown. Electricity had arrived in 1928. Cheap power and plentiful labor brought about a mining renaissance, and Georgetown was booming again. The Beebe-Eureka, Alpine, Clark, and Swift-Gold Ledge mines were running full tilt; commercial businesses opened; and the future looked good.

Another fire in 1934 took a heavy toll, shortening the recovery, and the severe winter of 1937–1938 marked the beginning of yet another slow period. Mining revival slacked off. Gold was again declared a nonessential industry. At the entry of World War II, mines closed and men went off to fight or work for higher pay in defense industries, causing more empty storefronts to appear.

Lumber underwent a resurgence as wartime needs then postwar building fueled demand. Stacked-lumber trucks replaced loaded ore carts. More sawmills began to appear until 13 mills were active at the close of World War II.

Progress continued for several decades. Black Oak Mine Unified School District gathered all the schools under one umbrella. Medical services expanded, adding dentists, optometrists, a medical center, and ambulance services. The first major supermarket opened in 1986, superseding all the small mom-and-pop markets. Two major banks opened branches to serve area residents.

Eventually, even the lumber industry began to wane as mills shut or consolidated. The eras of gold and timber passed, and Georgetown found tourism and recreation becoming its economic base. A reasonable drive from heavily populated urban areas, beautiful landscapes, bounteous rivers and streams, excellent hiking and horse trails, and nearby access to a natural primitive area opened new possibilities.

While it may never again achieve the size and bustle that started it, Georgetown remains an important link in California.

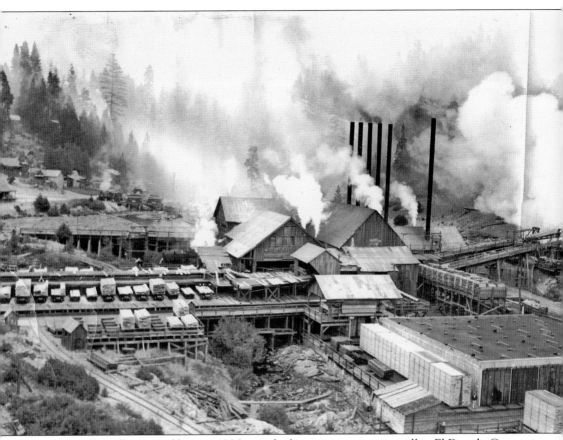

Pino Grande Mill, pictured here in 1936, was the largest operating sawmill in El Dorado County during its operations from 1900 to 1951. American River Land and Lumber Company was the first major lumber company to begin development of timberland on property purchased from Central Pacific Railroad just east of Georgetown in 1889. Although this company did not survive, others gladly took up the slack. Pino Grande was built in 1900 on the site of a small logging camp by El Dorado Lumber Company. By 1905, the company was producing up to 225,000 board feet of lumber daily. The sawmill continued to operate through several financial turnarounds. Mill ownership passed from El Dorado Lumber Company to C. D. Danaher Pine Company, and then to Michigan-California Lumber Company in 1918. The sawmill was abandoned and torn down after a new mill was constructed near Camino in 1951. (Courtesy Bob McPherson.)

One

THE PATH
TO GEORGETOWN

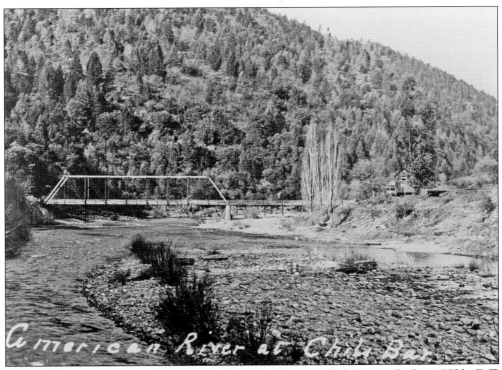

This bridge, crossing the South Fork of the American River at Chili Bar, was built in 1855 by E. T. Raun. It replaced a rough timber bridge, also built by Raun, at what was a ferry crossing operated by John T. Little. Stronger than the initial bridge, Raun expected the new bridge would withstand potential floodwaters. He was wrong. The bridge washed out in 1862, and its replacement washed out the following year.

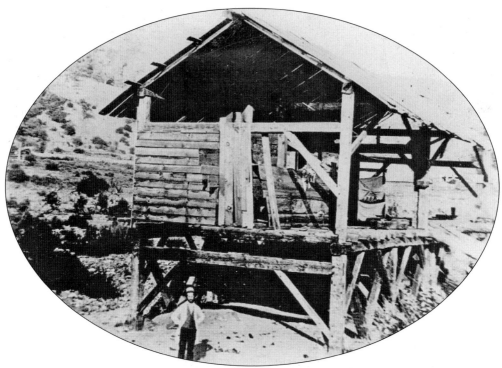

John Sutter's lumber mill at Coloma was nearly complete when a gold nugget was discovered in the tailrace, setting off a worldwide scramble for the California territories. (Courtesy California State Library.)

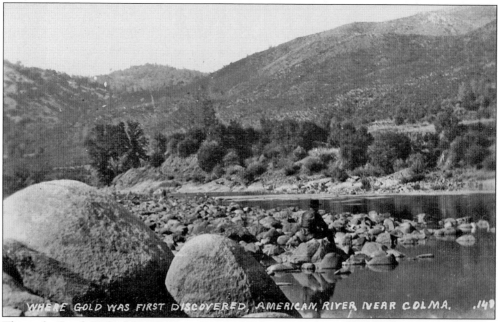

WHERE GOLD WAS FIRST DISCOVERED, AMERICAN RIVER NEAR COLMA. .149

This is the South Fork of the American River at Coloma just above the spot where James Marshall chose to begin construction of a lumber mill for Sutter. Miners descended upon this river branch before following the waters up the hill and into the tributary streams above.

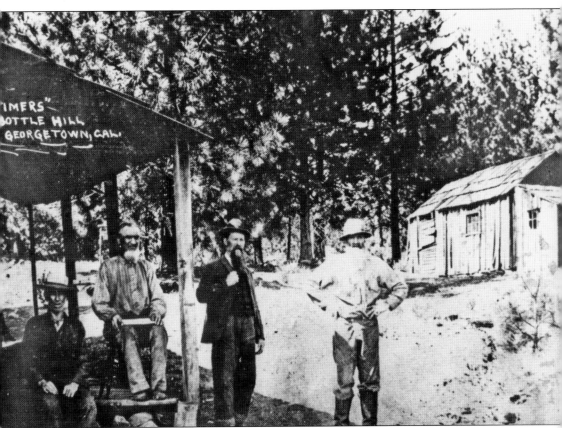

A ridge just above Georgetown proved to be an excellent gold-mining location. The original claim at Bottle Hill was founded by Thomas Pearson and Company in 1850. The story is they found an empty whiskey bottle under a bush. Claiming the bottle as a sign, the men dug in that spot, finding the beginnings of a gold channel described as "a big lake gone dry, leaving gravel and gold in its basin" (*Myths and Stories of the Georgetown Divide*, Rambeau and Moser, 1998). So many miners followed that a town sprang up on the spot, boasting stores, boardinghouses, hotels, and saloons. By 1882, the town was deserted. Fires, logging activities, and natural vegetation growth have completely erased all signs of the once-thriving community.

If luck is a critical factor in gold discovery, then probably the unluckiest man of that period was alleged discoverer James Marshall. After the sawmill shut down, Marshall wandered around the gold fields doing odd jobs and occasional prospecting. He undertook the lecture circuit for a bit around 1870, but while the acclaim was very satisfying to his ego, it did not fill his pockets. (Courtesy El Dorado County Museum.)

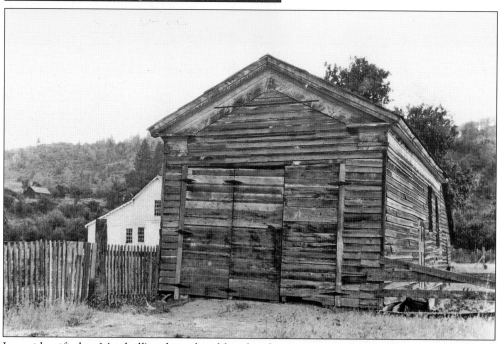

Long identified as Marshall's cabin, this dilapidated structure stood just off the main highway, south of Georgetown on the way to Kelsey, before collapsing into rubble. Having many friends in the Kelsey area, Marshall permanently settled there and eventually purchased the derelict Union Hotel, where he lived out his life.

Marshall built an operating blacksmith shop on the Gray Eagle Mine property south of Georgetown. Like many of his other investments, neither the mine nor the shop worked out for him, and the building was eventually abandoned and allowed to deteriorate. James Marshall died August 10, 1885; his assets were sold at auction. There was barely enough money raised to cover his funeral expenses.

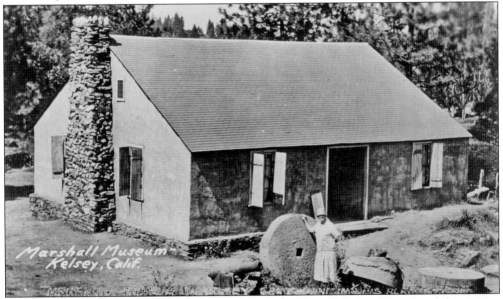

Margaret Kelley knew James Marshall when she was a child and was fascinated with his stories. After retirement, she was shocked at the deterioration of Marshall's old blacksmith shop and undertook to raise funds to save it. A stucco building was erected around the dilapidated structure, and historical memorabilia of Marshall and the Gold Rush were displayed. Kelley acted as both curator and historian, and after her death, the museum fell into disrepair.

The wild North Fork of the American River sported multiple bridges from earliest times, including this span. This may have been Lyon's bridge, a wire suspension bridge originally constructed at Condemned Bar in 1856 on the toll road from Auburn. Lyon dismantled and moved his bridge downstream below the confluence of the Middle and North Forks in 1865. Tolls were often collected on these bridges, providing lucrative livelihoods.

Early miners, even with families accompanying them, lived near where they worked as mines deepened and claim sites became less sporadic. Georgia Slide became a small community as well as a mining claim. Houses built were handy to the mines and the works that surrounded them. There were literally hundreds of tiny villages that sprang up across the Georgetown Divide in the early years of the Gold Rush. (Courtesy El Dorado County Museum.)

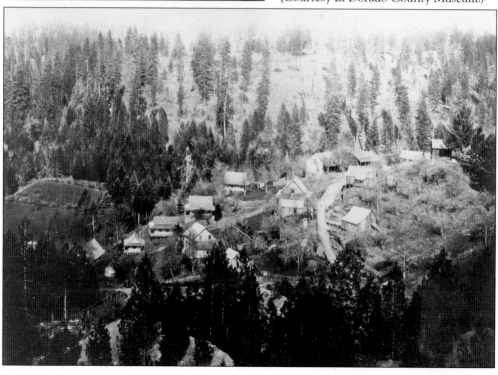

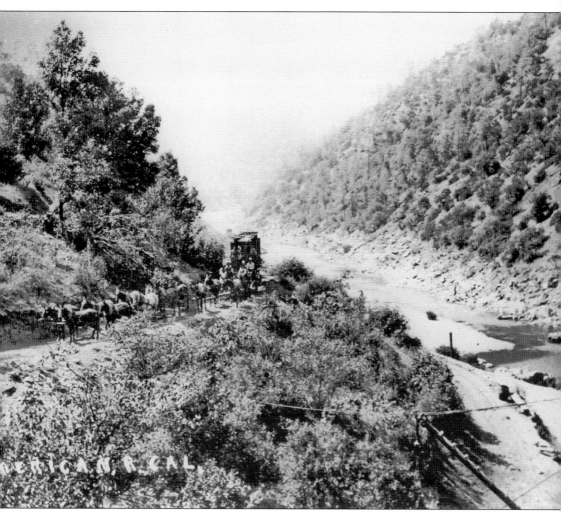

A loaded freight wagon pulled by multiple mule teams is starting up the Georgetown Divide side of Auburn Grade. The bulk of the miners making their way up from the river bars were either on foot or horseback, the roads being little more than paths. As the area grew more established, it became practical to begin using wagons, then stages, to haul freight and people into the mines and gold back out the Pioneer Stage Line. Alex Hunter, an agent, started a regular route from Georgetown to Auburn in 1854. The small town of Cool, at the top of the grade, was initially a stage stop, allowing a change of animals and rest for travelers. The animals all sported loud bells on their harnesses to warn oncoming traffic. Any driver requiring assistance getting his team out of trouble had to hand over a set of bells to his rescuer.

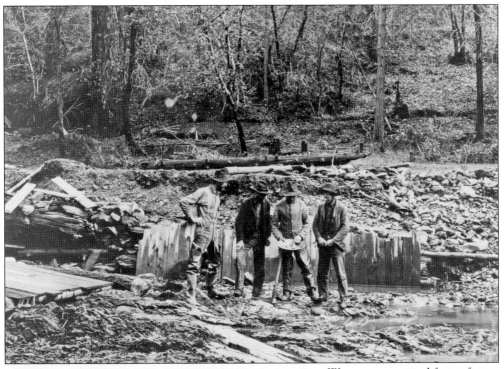

Water was a critical factor for separating gold from the rock and soil it was carried in. Nearly all the early mining looked to placer deposits, loose flakes that had been moved by water. The first finds were on the American River, so miners crowded onto the banks and rich gravel bars. These miners are pictured at Rock Creek around 1852. Miners eventually discovered that gold could be found almost anywhere, but they still needed water flow to separate the heavier gold from surrounding material. To supply water to the hilltops and ridges abundant around Georgetown, ditches were dug. Flumes, such as this Pilot Creek Ditch Company flume, were constructed to connect sections of ditch and crossed areas such as gullies where it was difficult or impractical to dig a ditch line. (Above, "Miners at Rock Creek" courtesy El Dorado County Museum.)

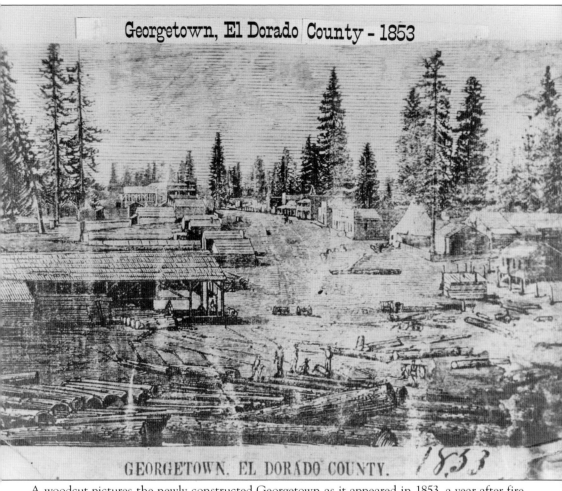

Georgetown, El Dorado County - 1853

GEORGETOWN, EL DORADO COUNTY. 1853

A woodcut pictures the newly constructed Georgetown as it appeared in 1853, a year after fire leveled the original George's Town built in a ravine just beyond the upper end of this picture. Woodside and Shanklyn's sawmill is in the foreground; many of the large sugar pine logs cut to clear the town site are seen still lying nearby. The Round Tent Saloon, on the site where the American Hotel was later built, is on the right just above center. Note the extra-wide thoroughfare down the middle, designed to save the town from annihilation by fire. This innovative plan, with Main Street designed to be 100 feet wide, is unique in Mother Lode towns. Original plans called for all side streets to be at least 60 feet in width but were later scaled down to current widths. (Courtesy California State Library.)

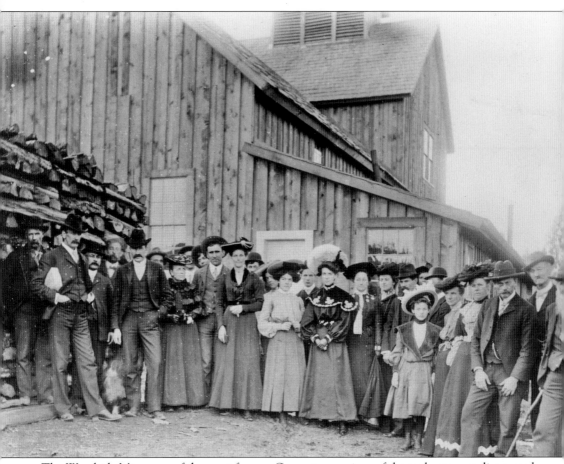

The Woodside Mine, one of the most famous Georgetown mines of the early era, was discovered when a large quartz boulder that interfered with log movement in Woodside and Shanklyn's sawmill yard was rolled over and found to contain several hundred dollars in gold. An open cut was made, a shaft was started, and some $30,000 was removed. An unidentified group stands in front of the mine buildings. Seeping water closed the mine for several years. It reopened from 1870 to 1876 but closed due to financial problems. Around 1900, it was again developed briefly. The mine was incorporated into the Beebe Mining Company's operations in 1935, and shafts extend under most of Georgetown on the northern end. The mine closed when the United States entered World War II, and the lot has been developed through the efforts of the Friends of the Arts and Historical Society and the Georgetown Divide Rotary Club into Woodside Mine Park. (Courtesy El Dorado County Museum.)

Two

COLLECTING THE WEALTH

This miner, photographed at Volcanoville, was typical of the men who came to Georgetown seeking wealth. The vast majority were in their prime, late teens to middle age, prepared to deal with the hard life of mining and rough living conditions. The earliest arrivals were sailors or in the military, men already in the California territory. (Courtesy of University of California, Berkeley.)

Placer deposits, the most common claims on the Georgetown Divide, are areas of loose gold in the form of nuggets or flakes that have settled after being disturbed and moved by many years of erosion. They are usually associated with rich river bars along the forks of the American River but may also be ancient stream channels discovered high on the Georgetown Divide. The Josephine Mine, first worked in 1851, was one of the most productive and longest lasting of the buried river channel mines. Quartz Canyon and Spring Tunnel were examples of rich gravel and quartz mines. Gold panning simply involves separating out the heavier gold grains from the lighter sand or silt. By adding water to make a slurry and then swirling the non-gold slurry slowly over the lip of the pan, the heavier gold dust and nuggets are left in the bottom—a method that is still used. (Sketch by Walter Drysdale, courtesy of Amy Drysdale.)

Canyons and gulches were the second-most-common mining claims along the Georgetown Divide. Claims were seasonal, with water forming natural land traps. As watercourses slowed, heavy gold minerals settled. Hudson Gulch, the first major claim staked on the Georgetown Divide, was this type of deposit. A gold rocker (or cradle) was a box with a single screen or multiple screens through which gold-bearing soil was sifted, usually with the aid of water being ladled or bucketed in. The box rested on curved skids, similar to a cradle, to encourage movement of the material. A sluice box is a trough-like recovering device with a series of obstructions or baffles, also called "riffles," along the bottom edge to trap gold. Water passed through streambed material shoveled into the upper end of the box. (Sketches by Walter Drysdale, courtesy of Amy Drysdale.)

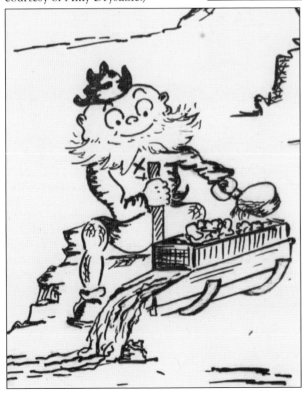

Load deposits are underground gold-bearing quartz veins mined using shafts following the veins. The Beebe Mine is a deep shaft mine that consolidated a number of earlier claims. Shaft mining expands to the more sophisticated hoist and vertical shaft design, allowing the miners to reach several levels. Seam mines such as the Beattie, Sailor Slide, and Georgia Slide are peculiar to this area and are also mined by deep-shaft development. (Sketches by Walter Drysdale, courtesy of Amy Drysdale.)

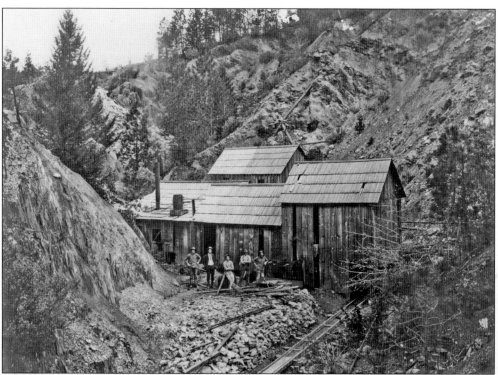

The Parson Mine on the Canyon Creek drainage was originally a placer claim, developed on the surface. Some material was excavated by primitive draglines, the material then sent through a sluice. The mine was reopened by the Gold Bug Company and developed into a shaft mine between 1896 and 1934. The mine was also briefly worked by hydraulic operations. (Courtesy El Dorado County Museum.)

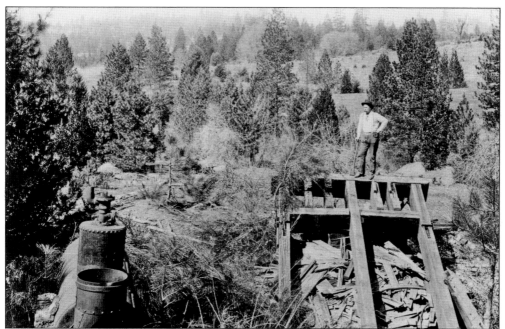

The Eureka Mine on the northern edge of Georgetown was first developed in the 1860s and became one of the highest-producing seam mines of the day. It had three parallel veins of gold-bearing quartz in 6-to-10-foot-wide swathes. The early workings, shown here, were more extensively developed through the 1880s and sporadically after that. The mine was also briefly explored for copper. Around 1900, the Eureka claim became part of the New Highland Gold and Copper Mining Company development. It reopened again in 1916–1918. The mine was incorporated into the Beebe Gold Mining holdings in 1932 and worked until World War II entry shut down all gold mining operations. The photograph below shows the rear of the mine building. (Both courtesy El Dorado County Museum.)

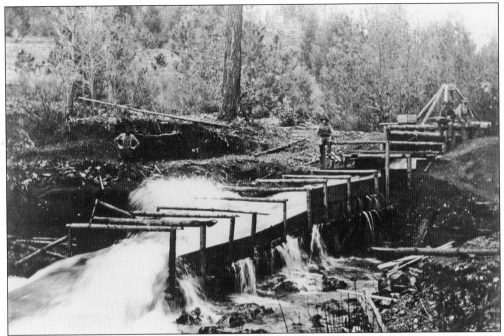

Pilot Creek Ditch Company organized in 1852 to bring water in ditches for miners and farmers. The company took over a private residence along Sacramento Street for the use of the company superintendent. This residence, now occupied by a play center, is the second-oldest structure in Georgetown. The ditch companies were consolidated under the umbrella of the California Water and Mining Company in 1872. (Courtesy El Dorado County Museum.)

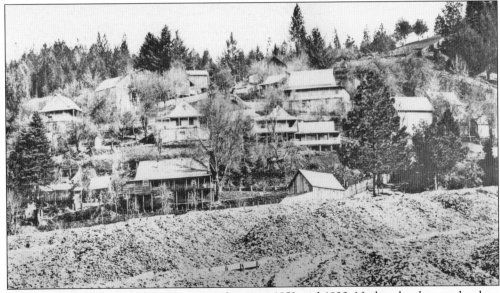

Georgia Slide was an active mining town between 1852 and 1920. No hotel, saloon, school, or church was in town. Residents were more than willing to go to Georgetown, less than 1.5 miles away, for education, entertainment, or worship. This area contained some of the largest seam gold deposits in the county, including Sailor Slide, Georgia Slide, Beattie, Blue Rock, Mulvey Point, Pacific, and Parsons claims, originally worked separately.

Gerhard "George" Barklage (above) found his way to Georgia Slide in the early 1850s. After mining for a few years, he assumed ownership of the Slide's only mercantile business and became one of the most active and prosperous businessmen. He continued some mining, sold real estate, and ran a sawmill just above Georgetown. James Flynn (right) was one of four brothers and three sisters who settled first in Georgia Slide, then in Georgetown. The last to arrive in the gold fields, James joined his brothers in gold mining at the Blue Rock. Flynn family members still own the claims. After 40 years of continuous mining, the amount of tailings that had accumulated in Canyon Creek was estimated at 2 million cubic yards.

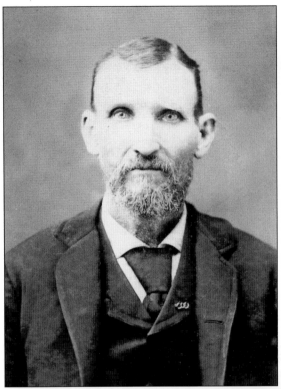

A native of Cornwall, England, William Davey brought his wife with him to the gold fields in 1860. Davey had been a tin miner in England and was renowned for his mining skills. He was a very social man and was always willing to share his knowledge and skills with other miners, making him a favorite source of mining information.

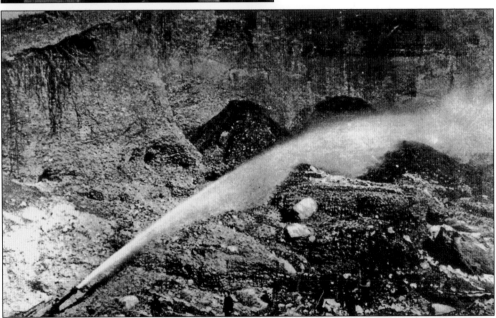

Hydraulic mining is washing gravel from a bank by sweeping a high-pressure stream of water against it. Because of the tremendous volumes of material washed through the recovery systems all at once, it has been estimated that as much as one-third to one-half of the gold moved by hydraulic operations was lost. Hydraulic operations had a devastating effect on riparian environments and agricultural systems until stopped by court order.

There is a small open cut in the north end of the Porter Mine, just west of Woodside Mine. The owner of the mine took out a nugget at the dark spot in the center worth $400 in 1903. First prospected in 1853 and abandoned shortly thereafter, it was reopened in the 1890s. New color appeared several feet below the old pit, but rising water eventually shut off further development.

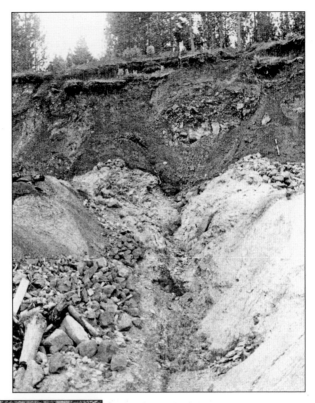

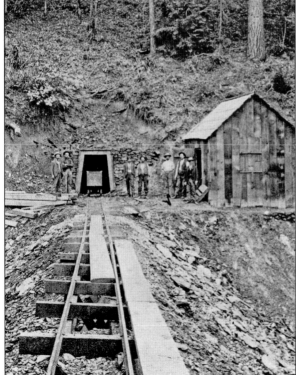

Mamaluke Hill Mine is a seam mine, slate interspersed with numerous quartz seams. The surface was first worked in 1851 by Klipstine and Keiser, who reportedly took out over $300,000 in gold. One of the largest recorded finds was in November 1855, when 20 pounds of gold were removed in three hours. The mine was continually worked until 1906.

The privately owned Athen Lode Mine near modern-day Buckeye was worked briefly in the 1930s when the big local lode mines, such as the Beebe-Eureka, Alpine, and Woodside near Georgetown, were being reworked. Expenses often outstripped production, and water intrusion was a constant problem for the owners. United States entry into war finally forced the mine to close. (Photograph by Walt Drysdale.)

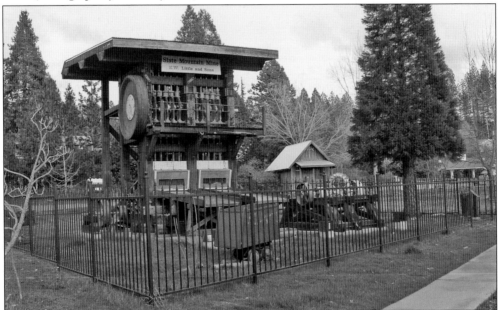

To collect gold ore from the rock that holds it in suspension, the ore must be crushed. Originally developed for tin mines, large stamp mills were adapted for gold mines. Heavy timbers with iron heads on the bottom, the "stamps" are raised on a rotating axle then dropped onto an ore and water mixture. Donated by owner Ray Little, the stamp mill used by Slate Mountain Mine has been restored by the Georgetown Divide Rotary Club.

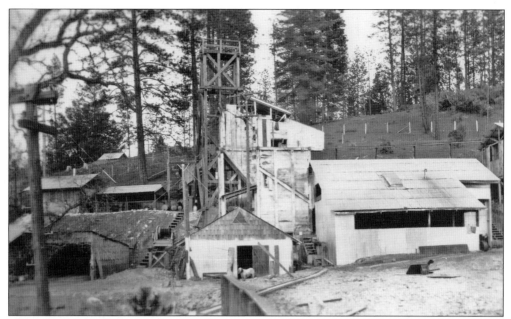

The 1930s Beebe Mine was a consolidation of several earlier claims; most worked in the Gold Rush, such as the Eureka and Woodside, Brooklyn, East Lode, and Iowa claims. The Beebe claim itself was first prospected in 1916. Initial operations began December 19, 1916, under G. E. Gregory, mine superintendent, and was closed down at the advent of World War I. The Beebe Gold Mining Company operated from 1932 until 1939. After 1939, there was only a small amount of gold produced, and that was mainly from cleanup operations. The company removed over 300,000 tons of ore, producing $1,200,465 in gold. An average of 20 men worked at the mine and the mill, which also processed the ore from the Alpine Mine. The Beebe had three main shafts—the Eureka, old Beebe, and Beebe No. 2—and reached 700 feet.

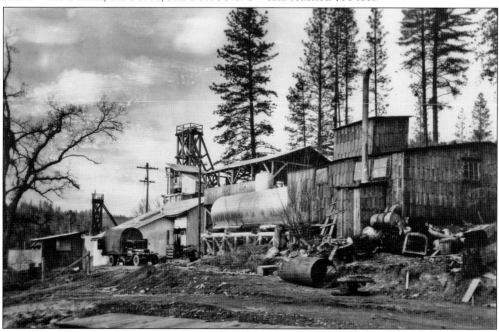

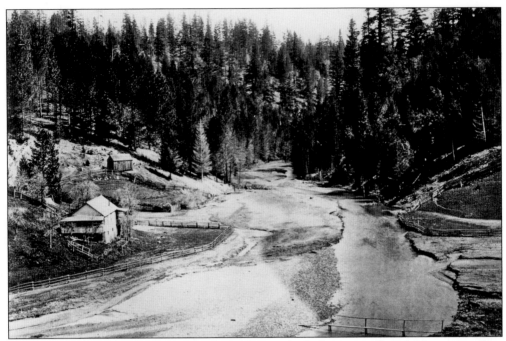

Twenty-mile-long Canyon Creek is at the bottom end of a long watershed fed by surrounding canyons such as Dark, Illinois, and Oregon where gold was plentiful. The first major gold discovery by the Hudson party in 1848 was along this waterway. The claims were so rich here that they were limited to 15 feet. (Courtesy El Dorado County Museum.)

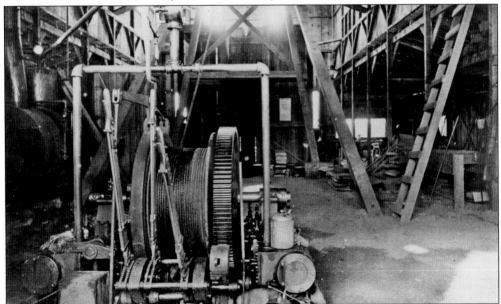

The Eureka Mine was one of the most productive quartz seam mines on the Georgetown Divide. By 1870, it was utilizing the steam-powered hoist and stamp mill shown here. A five stamp mill (five rock-crushing timbers mounted on a crossbar overheard) was located at the head of the main shaft, which is now covered by a large marker at the front edge of a small shopping center. (Courtesy El Dorado County museum.)

Three

SETTLING IN

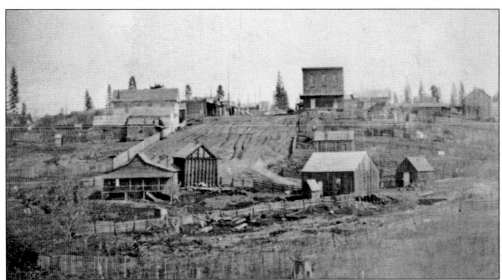

There is a theory that if a bucket of water were to be dumped in the middle of Main Street, the water would divide, with half flowing toward the South Fork of the American River and the other half flowing to the confluence of the Middle and North Forks. This town site looking eastward from modern-day Lower Main Street is the carefully chosen place for new construction of the town that burned in 1852.

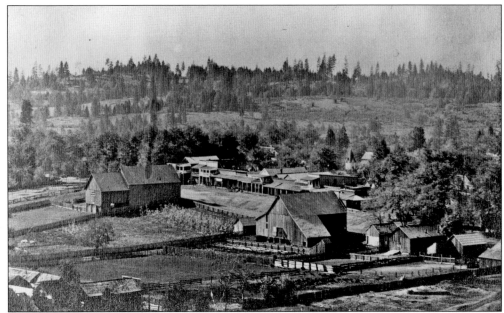

Still slightly raw in appearance, the new Georgetown pictured is just over four years old. An intense blaze, blamed on arson, moved so rapidly that firefighters' efforts were in vain, and the structures on the west side of the street were decimated. Broken, but not defeated, Georgetown citizens immediately pitched in to rebuild. (Courtesy California State Library.)

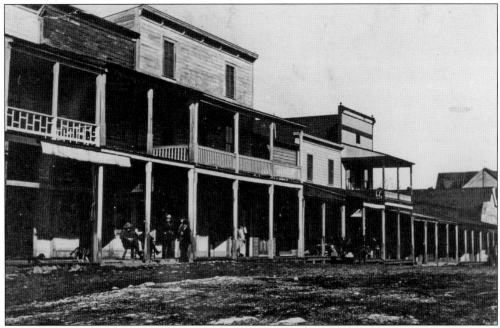

Georgetown burned again in 1859. Undaunted, inhabitants remained and continued to rebuild. The successful output of the surrounding gold claims made it worthwhile for not only the miners, but the businessmen and their families to remain and repeatedly rebuild. Main Street is pictured here, looking eastward, approximately nine years after the 1859 fire. The American Hotel is shown at the far right of the photograph.

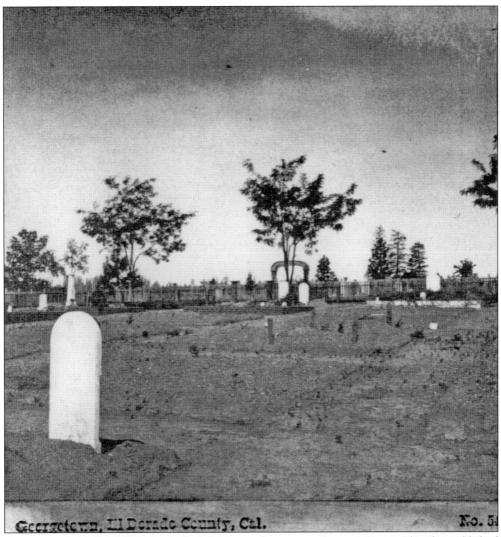

Georgetown, El Dorado County, Cal. No. 5

Georgetown's first cemetery overlooked the original town site, George's Town. Already established as a burial site, lot No. 3 of block 15 was set aside as a cemetery dedicated to public use on March 30, 1868, as part of an official township survey. Nearly 20 years later, a public meeting appointed an official cemetery committee of three—justice of the peace E. L. Crawford, Frederick Schmeder, and C. M. Fitzgerald—to take charge of the cemetery business, overseeing proper road layout and fence repairs, superintending burials, and keeping track of all the records. Thomas Warner died on July 1, 1848, and is believed to be the first person buried in the Georgetown Cemetery. There is no longer any marker on his grave. The oldest existing headstone still standing in the cemetery belongs to Isaac Green, a native of Illinois who died on August 4, 1850.

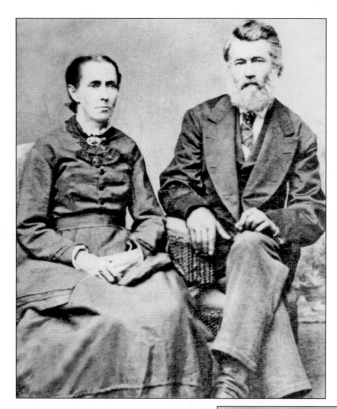

Reuben Demuth learned the miller's trade in Michigan. He came to the Georgetown area with his brother-in-law to hunt gold. The brother-in-law was successful; Reuben was not. He established a general mercantile and found his niche. He sent for his fiancée, Margaret Griffin, who traveled by stage, mule, steamer, and wagon to meet Reuben. They began a gristmill operation, the first flour ground in El Dorado County. (Courtesy El Dorado County Museum.)

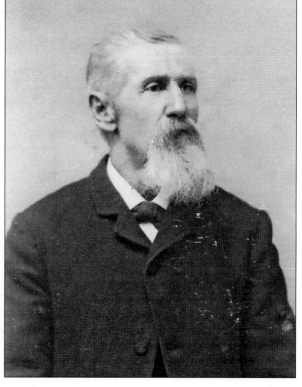

George Roelke came west in 1852 and engaged in making long toms for other miners. Long toms were similar to rockers, just much larger, with riffle bars nailed to the bottom. The Roelkes owned and operated Parker House Hotel, which he had purchased in 1863 for a mere $450, and turned it into a popular boardinghouse. (Courtesy El Dorado County Museum.)

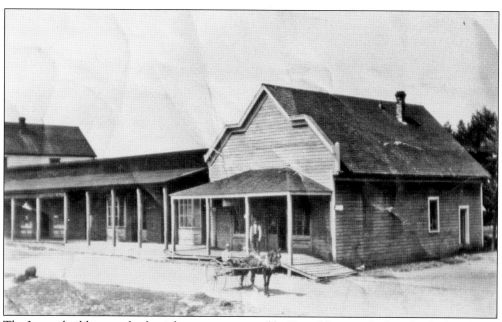

The Jerrett building on the far right was constructed by Daniel Jerrett who bought the brick-built store on the corner of Main and Orleans Streets in 1870 and opened Jerrett's Mercantile. Fire destroyed Jerrett's business in 1897, but he promptly reconstructed a frame building and was back in business in a month. The business closed in 1914, remaining vacant until reopened in 1934. Closed again when World War II started, the building was used for war-related work, such as the making of surgical dressings. Since 1952, the Jerrett building has been a restaurant. Until fire destroyed the wooden parts, the Filipini Store (below) had been the oldest operating store in El Dorado County. Built by Massino Pedrini, it was known as "Bill Tell's" store. His nephew Reynaldo Filipini was first a clerk there, then a partner, and eventually took over the business.

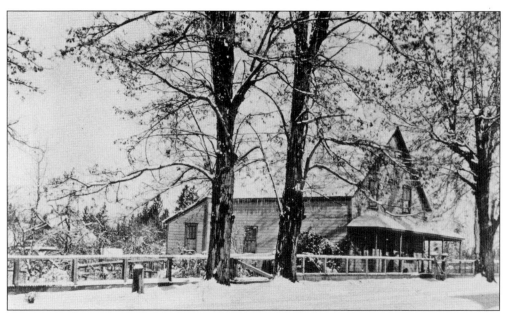

British couple George and Catherine Brown and Ireland natives Patrick and Mary Morgan began mining gold in the very early years. Their respective children, Peter Fitzpatrick Morgan and Mary Ann Brown, married. The young couple moved to the Browns' home on Church Street, and Peter became a ditch agent for the Loon Lake Water Company. The house is still occupied by Morgan descendants.

Frederick Schmeder came to Georgetown in 1859. He was a carpenter, but first attempted mining as a living. Not successful at mining, he used his carpentry skills instead. He became one of the most prolific early-day Georgetown contractors and constructed many of the prominent public buildings still seen in Georgetown. An extensive use of gables is a Schmeder trademark. His daughter Louise lived in the house until her death in 1977.

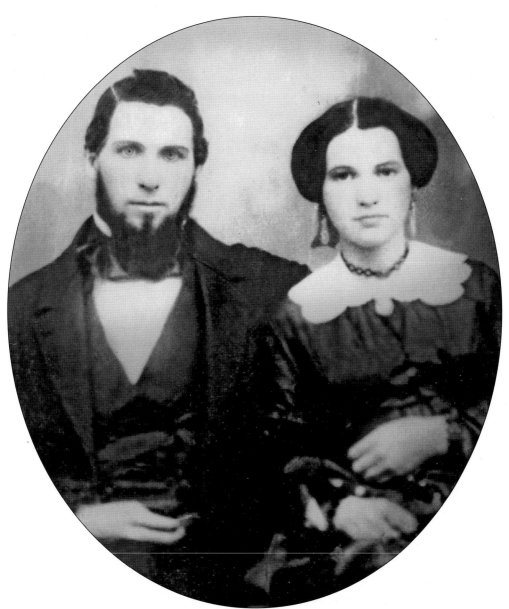

Lewis Bryant traveled to Georgetown with his brother Nathaniel in 1852, and they began mining operations as Bryant and Company in Oregon Canyon. The brothers reported taking out one huge nugget weighing over 40 ounces in the short (less than 200 yards long) Devine Gulch, on the east side of the canyon. Lewis met his wife, Betsy A. Finney, at Mamaluke Hill. They married in 1855 and settled in Georgetown, where Lewis became quite active in civic and community affairs. He and his brother, with 12 others, formed the Bay State Company, named for their native Massachusetts, and began mining at Mamaluke Hill. Bryant reported removing more than 1,000 carloads of gravel from their 500-foot tunnel, averaging $20 per load. Lewis reportedly possessed a splendid bass voice and had sung at nearly every funeral in Georgetown since 1852. He estimated he had sung at more than 1,000 such occasions. (Courtesy El Dorado County Museum.)

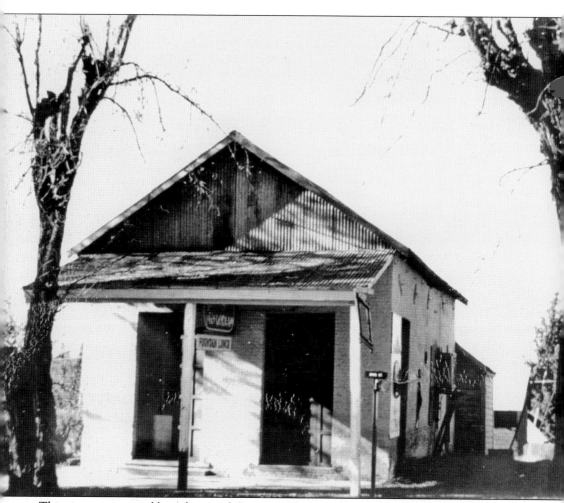

This site was occupied by Adams and Company Express office, Michael Murphy resident agent, in 1853. The company went bankrupt in 1854 and closed, eventually becoming the banking house of W. H. Pratt the following year. A terminal in the building supplied a branch line for Alta Telegraph. The structure burned in 1858 and was replaced by a frame building occupied by a bookstore, which burned in 1869. The new building (pictured) constructed the following year of "fireproof" brick was a store before California Water and Mining Company purchased it for its offices in 1872. A merger with Truckee River General Electric in 1912 moved the offices to property owned by the manager George C. Devore, and the building was purchased by Harry Gravelle. It was the town's telephone office from 1934 to 1939, briefly a butcher shop, and finally the Corner Kitchen coffee shop in 1950. It has remained a coffee shop through several owners and name changes.

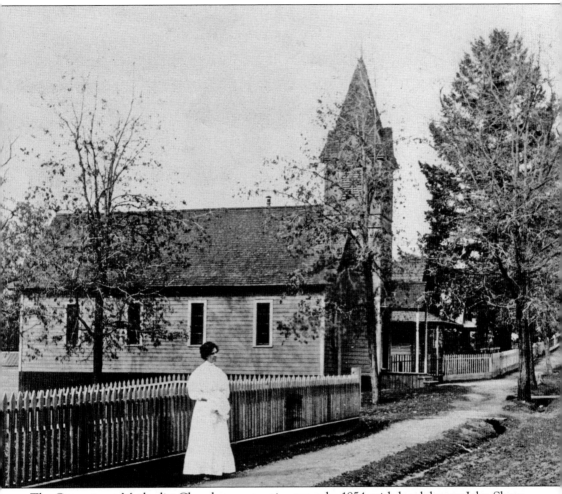

The Georgetown Methodist Church was an active group by 1854, with local deacon John Sharp acting as pastor. Two meetings were held every Sabbath and at least once during the week. The congregation had problems finding a building of its own. The first church burned, so members began meeting in a building they shared with other denominations. This building was then sold, forcing the group to meet at the schoolhouse. Funds were raised to construct a church on the north side of Church Street near the school, but financial problems foundered that attempt, and the structure was not completed. The congregation shared the old Union Church until the town trustees ordered the deteriorating building to be torn down. The Methodists initiated plans for a new church building to be constructed on the corner of Church and Placer Streets. A cornerstone was laid in 1889, and the building debt was completely paid off by the time the church was dedicated on June 9, 1889. Ruby Green is standing in front.

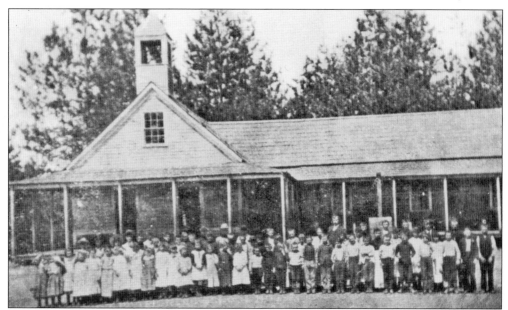

In 1853, Mrs. Ray opened the first school in her home; there were seven pupils. It was soon determined by Tom Gibbs in "Reminiscences of Early Georgetown," which appeared in the *Georgetown Gazette* on April 4, 1903, that Georgetown was going to be a "real town," and a permanent educational system was needed. A T-shaped schoolhouse was constructed at the end of University Street (now School Street), far enough from the saloons and business section of town where pupils would not have their lessons disturbed by any rough talk emanating from those establishments.

The Anderson family stretches back eight generations, beginning with the Gold Rush and the Hughes/Buchler families. Katherine Buchler homesteaded 160 acres of land just south of Georgetown in 1893. Her son-in-law Frank Hughes built two homes on the property, one for her and one for his own family. Buchler's house is currently owned by her great-great-great-grandson Larry Anderson. Frank Hughes's home is owned by Larry's father, John "Jack" Anderson.

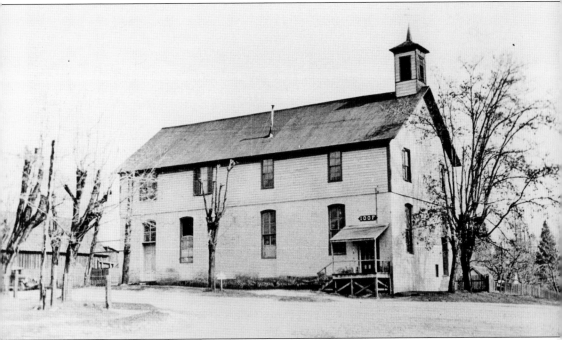

A local butcher named Joseph Olmstead married the widow Eliza Balsar, for whom he erected a three-story building on the northeast corner of Main and Sacramento Streets in 1859. The named Balsar House was a combination hotel and restaurant, with the first two stories utilized as the hotel and the upper floor as a dance hall. A veranda went completely around the building with French doors opening onto it from each room. Impressive as it was, the hotel was a failure. Joseph Whiteside, who had taken a fortune out of nearby Crane Gulch, bought the structure in 1870, removed the top two stories, and converted it into an opera house called Whiteside Hall. It had a concave ceiling constructed of narrow-width lumber with a bottle-bottom shape set in at intervals along the center, which supposedly made it an acoustically sound building. The opera house was also a failure. The mercantile firm of Harmon Sornberger and William Lane opened a store in the building in 1878 before selling to the International Order of Odd Fellows (IOOF) in 1879.

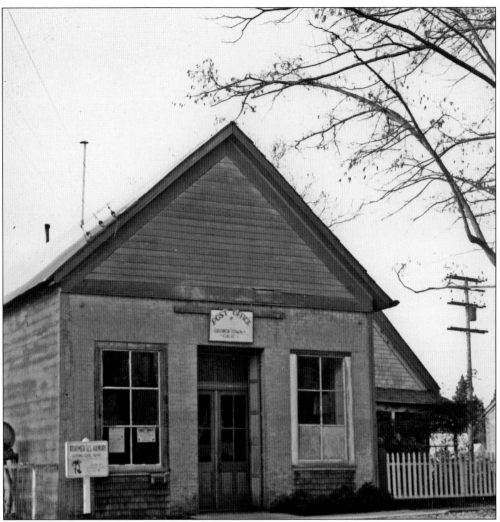

During the early years of the Civil War, mine owners and local businessmen feared the intrusion of Southern troops seeking the rich gold sources. Northern military agreed and established home guards in gold country communities. The Georgetown Blues was formed as a quasi-military group in 1859 as Georgetown's Union Guard. Their uniforms were regulation caps, blue shirts, and black trousers. Each member was to provide his own firearm and ammunition. The armory building was constructed in 1862 as an office and storage facility for the Blues. The Georgetown Blues was officially recognized as Company A, 2nd Infantry Division, 4th Brigade of the Union army in 1864. The unit was mustered out of service June 9, 1868. Afterward, the building held miscellaneous detritus until it was heavily damaged in the 1869 fire, when it sat vacant until being remodeled for use as a Catholic church in 1881. After 1924, the building saw use as a library, post office (pictured), real estate office, and small café.

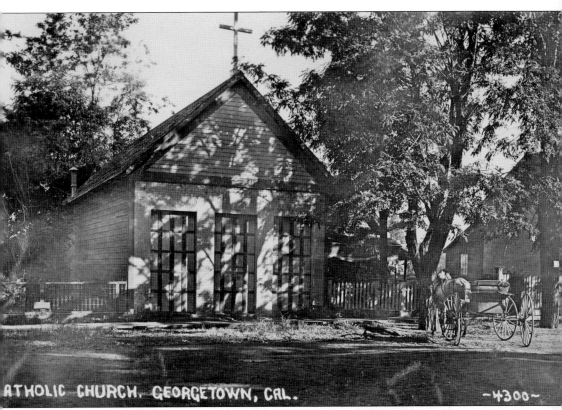

ATHOLIC CHURCH, GEORGETOWN, CAL. ~4300~

There was a very early Roman Catholic presence in Georgetown. The first Masses were conducted in 1850 by a priest traveling to the community from Sacramento. In 1853 an official Catholic parish formed in Georgetown. The first church was at the northeast corner of Church and Placer Streets. This structure burned in 1858. Rebuilt, the second church was also burned beyond repair in 1869. With a dwindling population, it was uneconomical to rebuild at that point, and area Catholics were served by itinerant priests conducting services in private homes or available social halls. In 1881, the empty armory building on Main Street was converted into a Catholic church for St. James Parish by Frederick Schmeder and Fred Brown. This structure was used until 1923. Fr. Patrick O'Kane served as resident priest for a significant portion of that time, from 1901 until 1921.

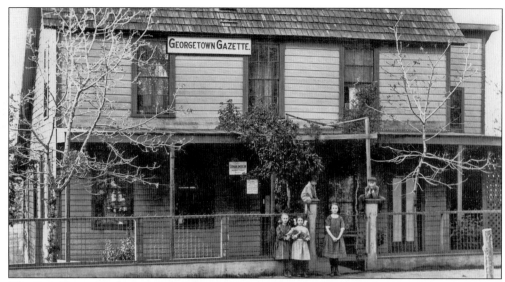

The first Georgetown newspaper, the *Georgetown News*, was established in 1854 to advance building a wagon road up through Georgetown to Nevada's Carson Valley. It ceased publication in 1856. The *Gem* survived slightly longer, from 1872 until 1877. Horace Hulbert launched the *Georgetown Gazette* in April 1880 from his residence on Church Street. His daughter Maude ceased publication in 1924. Maude's daughter Amy Drysdale revived the *Georgetown Gazette* for about three years, from February 1933 to December 1935. The 1961 *Town Crier* was adjudicated, allowing the paper to print legal notices, a significant source of income. When new owners bought the paper 10 years later, it was named the *Georgetown Gazette and Town Crier*. Now, the *Town Crier* designation has been dropped from the masthead, but the newspaper continues publication. The children in front of the Gazette building are, from left to right, Doris ?, Ivy Butler, unidentified, Amy Horn, and Larry Murdock.

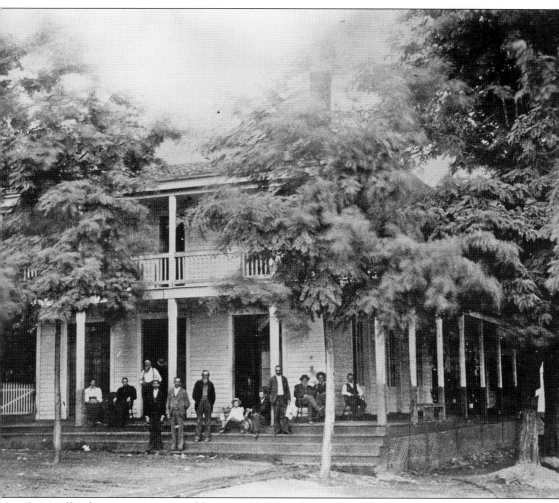

Originally, this site was occupied by a gambling establishment. The Sharp residence was built after the saloon burned. The home was converted by Joseph Williams into a rooming house known as the Orleans Hotel. In 1862, Sam Currier changed the name to the American House. Raymond Bundshuh was engaged in mining, the brewery business, and several other pursuits before associating himself with George Heuser, a former baker, in the early 1860s. The two men either converted the existing structure or constructed a new building here and called it the American Hotel, a designation that stuck for over 100 years. Heuser died in 1876, and his widow married the bachelor Bundshuh. Bundshuh died in 1881, and his widow and her two sons, George Heuser Jr. and William Heuser, continued to operate the hostelry. George Jr. went on to serve 16 years as a county supervisor from the fifth district encompassing Georgetown, serving eight of the years as chairman of the board. The hotel escaped being burnt in the 1897 fire but caught fire internally in 1899, sustaining heavy damage.

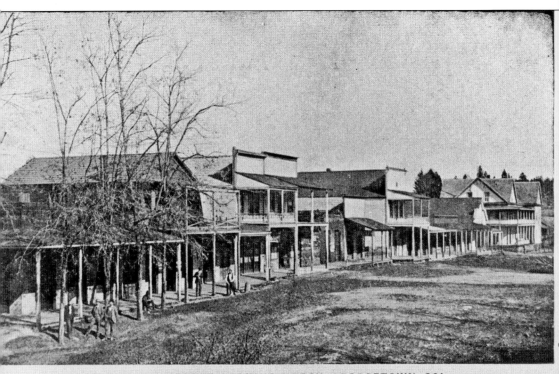

NO. 103—MAIN STREET, LOOKING NORTH, GEORGETOWN, CAL.

A photograph shows Georgetown as it appeared after reconstruction from the devastating fire in 1856. One of the most significant early Georgetown pioneers was William Thomas "Tom" Gibbs. Not only does his name crop up regularly in early history accounts, but his observations often offer the most complete views of early Georgetown. Trained as a blacksmith, Gibbs joined the Gold Rush in 1850, mining the American River, then the rich Oregon Canyon. Gibbs built the first long tom on the Georgetown Divide. He took up business in a small grocery store and served as postmaster. He was one of the three men chosen to find a new site after the 1852 fire wiped out the town. The first wedding performed in Georgetown united Gibbs and widow Cynthia Turner. He was a director for Pilot Creek Ditch Company and a school district trustee. His name appears as a charter member of a great many of the early Georgetown organizations. Gibbs moved to Oakland in 1879, leaving Georgetown.

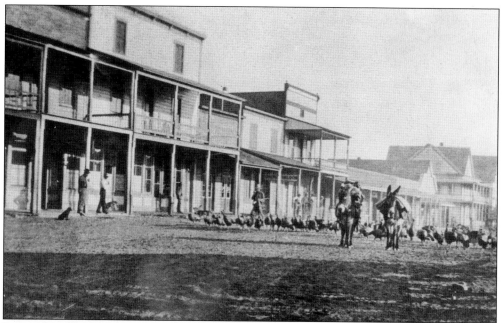

Pictured is a flock of domestic turkeys, owned by Bob Jerrett, being transferred from higher and cooler pastures back home to his ranch at Penobscot. The son of pioneer Georgetown butcher Daniel Jerrett, Robert S. Jerrett and his wife, Eva, owned and operated the Wentworth Springs Hotel and Resort for almost 40 years. The Jerretts were famous for their hospitality and good food at the popular resort.

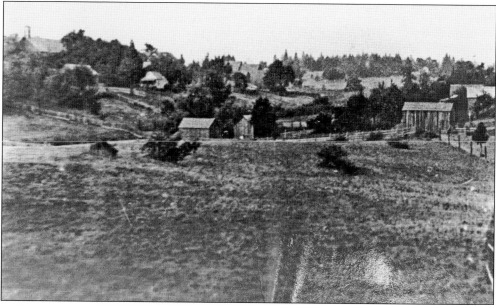

A Georgetown street is named for farmer Edson Harkness. In 1852, Harkness very successfully started a small nursery and vegetable gardens, adding orchards in 1858. His success spurred others, and it became apparent that local soil was excellent ground for grapes vines and apple and peach trees. His estate-settlement papers in 1866 reported that approximately 4,000 grape vines and 1,200 fruit trees were in various stages of development on his ranch.

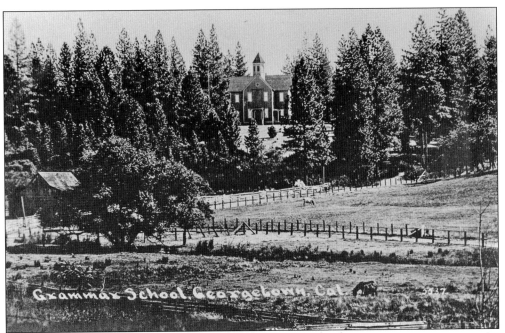

Grammar School, Georgetown, Cal.

By 1889, the original Georgetown School had been outgrown. After years of heavy rain erosion, the grounds and school building were badly weathered, so citizens voted to build a new schoolhouse. Three potential sites were offered. The final choice, 5 acres on Railroad Hill, was well away from the center of town and clear of the noisy mining operation and lumberyard in the flat below. Frederick Schmeder was awarded the construction contract and a spanking new two-story schoolhouse, with an octagon-shaped bell tower and Schmeder's trademark gables, opened for classes in 1890. The Georgetown School census for the year ending April 30, 1909, according to trustee Louise Schmeder, was 36 boys and 34 girls, making a total of 70 students. There were an additional 32 children under the age of five in the district.

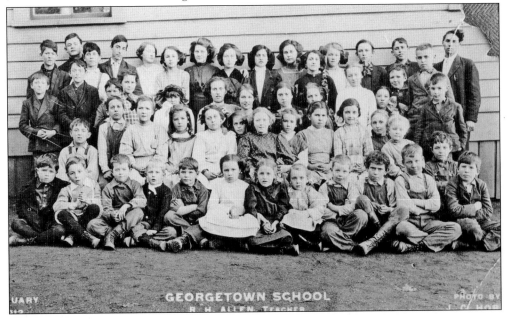

GEORGETOWN SCHOOL
R. H. ALLEN, TEACHER

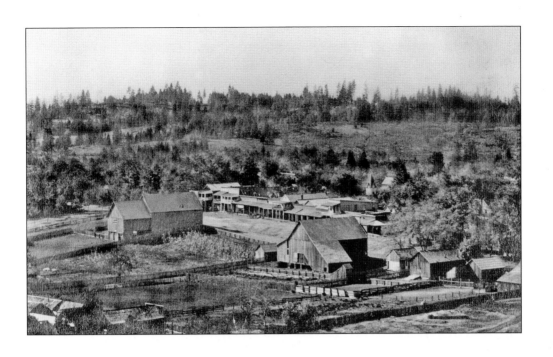

Both photographs were taken after the 1897 fire from the best vantage point in Georgetown, the second story of the new Georgetown School looking down on Georgetown. Standing in what had been an orchard, the photographer looks down on Georgetown in the above image taken in 1898 or 1899. Building remnants from the Woodside Mine are at the upper left. Taken at least one year later, the fence line in the below photograph has been replaced, and a slightly different perspective is shown.

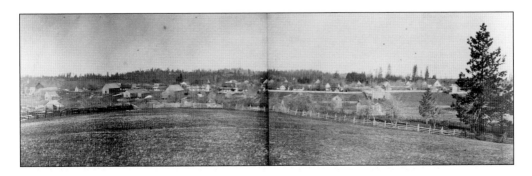

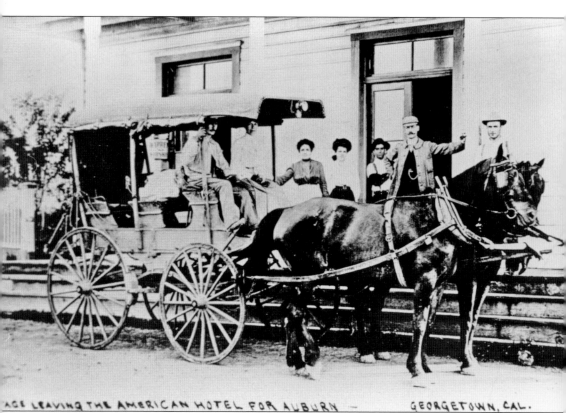

...AGE LEAVING THE AMERICAN HOTEL FOR AUBURN — GEORGETOWN, CAL.

The first stage line in Georgetown was established by Francis Graham between his store and Coloma in 1850. Another stage line, owned by James Burch and a Dr. Thomas, ran a regular route between Georgetown and Sacramento. In 1851, Vanguilder and Hunter's Express county-wide service began; mail collection at either end made the business highly profitable. Wells Fargo and Company bought it out three years later and established branch offices throughout the county. Multiple "teaming" companies, hauling freight and supplies, began to spring up. The teaming wagons were a familiar sight on the Georgetown Divide up to the 1920s, when the automobile made horse-drawn conveyances obsolete. Passenger service was not nearly as competitive, although Chet Freeman's daily stage line between Georgetown and Placerville and I. E. Terry's stage line to Cool provided daily service for the traveling public. Charles Joseph Rupley purchased both these stage lines around 1900. When automobiles hit the market, Rupley became the local Buick dealer and eventually phased out stage lines entirely, moving to Placerville to become a Chevrolet agent.

Four

SOME OF THE PIONEERS

Carpenter Shannon Knox built a crude log cabin in 1852, which burned a few months later. Knox's skills were immediately put to use rebuilding the town. He constructed himself this fine two-story home on the corner of Main and Sacramento (Highway 193) Streets. The interior stair rails, parlor arch, and sliding doors were shipped by a sailing vessel around Cape Horn. The home resisted all subsequent fires, making it the oldest surviving structure in town.

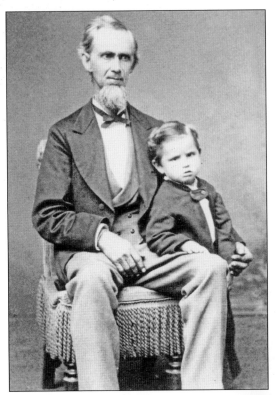

W. C. Benjamin opened a harness- and saddle-making shop in early Georgetown, furnishing leather springs used in early Wells Fargo stagecoaches operating in the area. His son William R. Benjamin was reputed to be the first Caucasian child born in Georgetown. Benjamin sat on the Georgetown School Board and two water boards and participated in nearly all philanthropic organizations. (Courtesy El Dorado County Museum.)

Thomas Milbourne Reed was instrumental in organizing the first Masonic Lodge in Georgetown in 1853. He was also secretary of the El Dorado Ditch Company, the primary supplier of municipal water supplies, serving as postmaster, county treasurer, county supervisor, and justice of the peace along the way. After bar admission, he served as prosecuting attorney and deputy collector of internal revenue. (Courtesy El Dorado County Museum.)

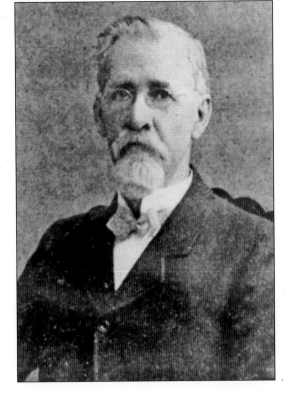

Margaret and Mary Stanton were the children of pioneer Edward Stanton who settled into Georgia Slide in 1858; his wife and children joined him four years later. Edward was the last of the Georgia Slide pioneers, moving his brood into Georgetown in 1915 but still traveling back to Georgia Slide until the mines were closed in 1917. Pictured are Margaret "Maggie" (right) and Mary (below). The youngest Stanton child, 13-year-old Bridgett, was one of five fatalities in the arson-caused 1869 fire. Maggie died of influenza. Her older sister Catherine nursed Maggie until her death, fell ill, and died three weeks after her sister. Mary, as did her sisters, remained a spinster her entire life. (Both courtesy El Dorado County Museum.)

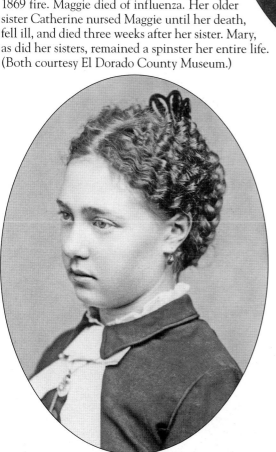

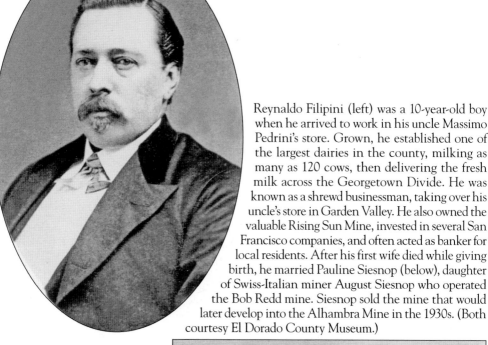

Reynaldo Filipini (left) was a 10-year-old boy when he arrived to work in his uncle Massimo Pedrini's store. Grown, he established one of the largest dairies in the county, milking as many as 120 cows, then delivering the fresh milk across the Georgetown Divide. He was known as a shrewd businessman, taking over his uncle's store in Garden Valley. He also owned the valuable Rising Sun Mine, invested in several San Francisco companies, and often acted as banker for local residents. After his first wife died while giving birth, he married Pauline Siesnop (below), daughter of Swiss-Italian miner August Siesnop who operated the Bob Redd mine. Siesnop sold the mine that would later develop into the Alhambra Mine in the 1930s. (Both courtesy El Dorado County Museum.)

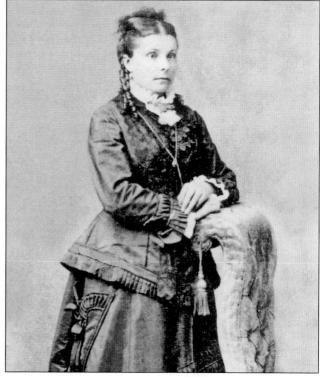

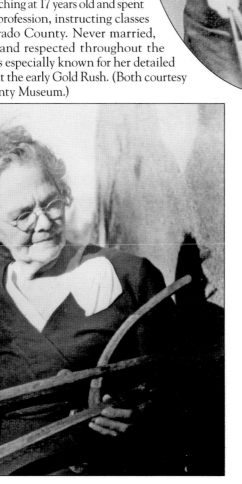

Margaret Kelley (seen at right and below) was a small child when James Marshall moved in with her parents, Patrick and Susan. She was fascinated by the famous man. He, in turn, was captivated by the attentive child and was quite willing to allow her to accompany him when he gave lectures or rode in parades. She looked after Marshall in the last years until his death. Kelley began teaching at 17 years old and spent her life in that profession, instructing classes all over El Dorado County. Never married, she was loved and respected throughout the county. She was especially known for her detailed knowledge about the early Gold Rush. (Both courtesy El Dorado County Museum.)

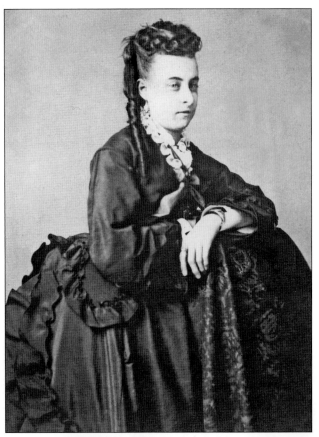

In 1886, Sierra Nevada "Vade" Phillips Clark purchased property containing hot springs near the Rubicon River from former miners John and George Hunsucker. The Hunsuckers had been bottling the Rubicon Springs water and selling it. Vade built a two-and-half-story hotel at the Rubicon Springs with curtained-glass windows, 16 small rooms, and a parlor with horsehair furniture and a foot pedal organ. Rubicon Springs Resort was an instant success. Vade sold the resort in 1901 but continued to manage it for another four years. The first automobile drove into the Rubicon Springs in 1908, the year a tremendous flash flood raised the river 8 feet overnight, dumping mud and water on everything and nearly washing the hotel and outbuildings away. Operations ceased in the mid-1920s, and snow collapsed the building in 1952. (Left, courtesy El Dorado County Museum.)

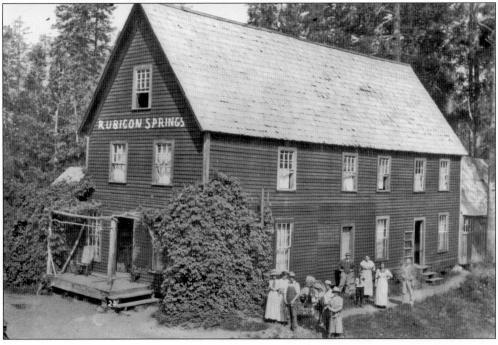

The daughter of *Georgetown Gazette* founder Horace Hulbert, Maude Hulbert Horn learned to set type for the newspaper at nine years old. She was a full-fledged reporter by 14 and acted as publisher at 19 while her father went prospecting. By 1895, she was solely in charge, one of only 50 female editors in California. A very small woman, Maude was unable to operate the heavy presses alone and hired printer John Horn. They were married two years later. Maude raised three children; studied French, Shakespeare, astronomy, and shorthand; grew and sold cherries as a sideline; and submitted multiple articles to other newspapers. She was the first female justice of the peace in Georgetown and was a notary public for over 30 years. John taught dancing, sold insurance, and did photography and the printing business. (Both courtesy El Dorado County Museum.)

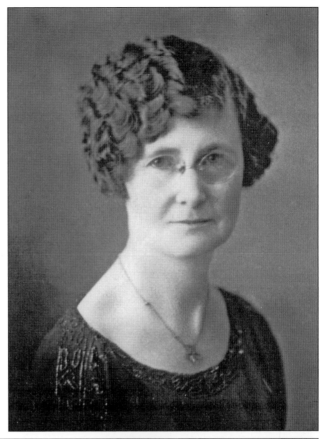

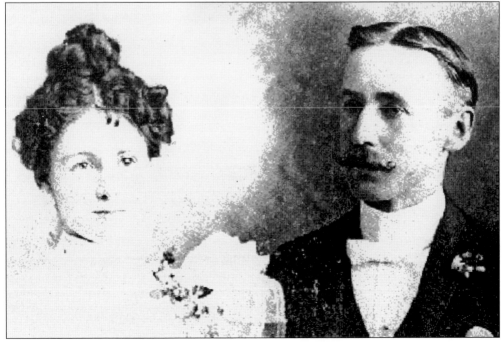

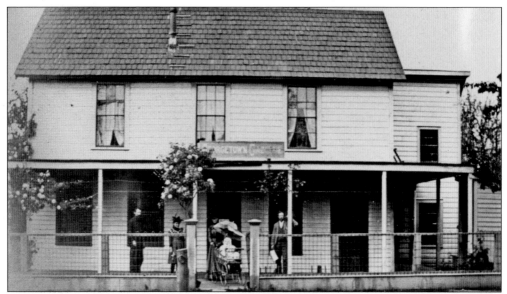

The *Georgetown Gazette* was published from the Hulbert residence on Church Street. Publisher Horace Hulbert printed 500 copies of the first edition; the very first copy was sold to Dr. Cullen Spencer, who paid a "shiny half-dollar" for it, according to Tom Gibbs in the aforementioned "Reminiscences of Early Georgetown." The average weekly circulation was 600. Hulbert's daughter Maude and son-in-law continued to live in the house and publish the newspaper. Maude closed the newspaper down in 1924.

The Bayley house, built by Alcander John Bayley in 1861, featured 24 rooms in its three stories and 10,376 feet of living space. Unfortunately the hotel remained mostly empty and became known as Bayley's Folly. Bayley was, however, a very successful farmer and was the first in the county to make use of such farming machinery as the reaper, mower, and threshing machine. He established Pilot Hill Grange, California Grange No. 1.

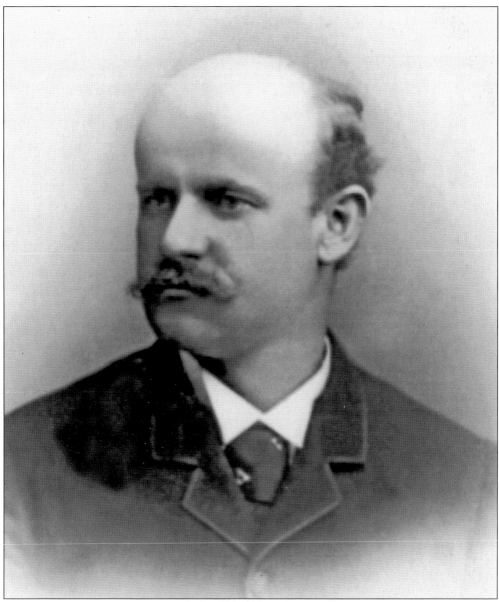

Benjamin Franklin "B.F." Shepherd arrived in the gold fields as a young man, and within 25 years, it was said he was actively involved in the major part of trade in Georgetown. He began initially assisting in a saddle and harness shop, branching out to the general variety store business. As drummer boy, Shepherd was one of the youngest members of the Georgetown Blues infantry formed just before the Civil War. After the 1869 fire, he rebuilt his primary business in a brick structure on the corner of Main and Placer Streets and expanded, adding a stock of drugs to his general store. He was also proprietor of the Pioneer Hotel. The first telephone in town was housed in Shepherd's store in the 1890s. Shortly after the 1897 fire, which gutted his business, Shepherd turned his operations over to Harry Gibbs, who had worked for him for several years, and retired to Fresno. (Courtesy of El Dorado County Museum.)

Alessandro A. Fransioli, commonly known as Alexander Francis, opened a butcher shop in partnership with Godfrey Schmeder in the early 1870s. The partnership dissolved, and Francis continued to operate the meat shop, along with a saloon and a livery until the fire of 1897. He retired briefly following the fire but returned to the butcher shop firm where he worked until his death in 1921. His son Sartor (below) went into business with his father, rebuilding the butcher shop in the ashes of the old one and another livery stable next to the IOOF hall. Francis built the fine residence above in 1908 on the site where the last structure of Georgetown's Chinatown stood, until all the Chinese homes and businesses were torn down in May 1908.

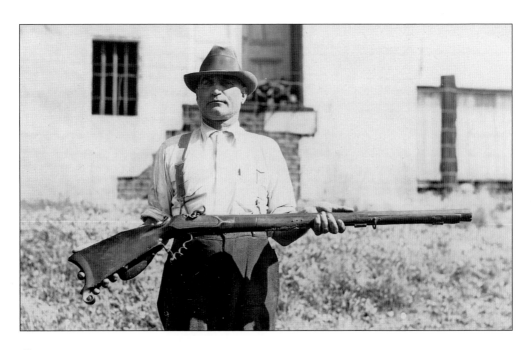

Jonathon Lauman came from his native Norway in 1850, staking a claim south of Georgetown. Unusual for the time period, he married a local native girl. They homesteaded 80 acres on Spanish Hill and began to raise fruits and vegetables to supply nearby Spanish Flat. Lauman was a friend of James Marshall, his name appearing as witness on several patent mining claims Marshall filed. (Courtesy of El Dorado County Museum.)

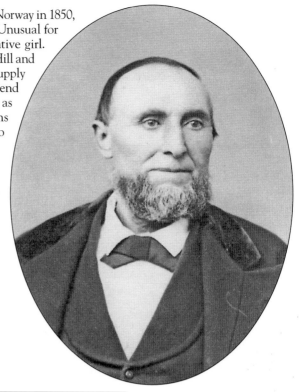

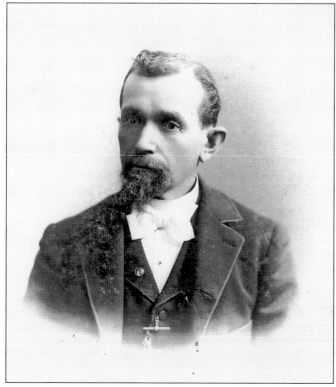

Godfrey Schmeder abandoned mining to partner with Alexander Francis in City Market. When the partnership dissolved, Schmeder went into contracting with his brother Frederick. Contracts were scarce in 1893, and Schmeder returned to the butcher business, taking over Mr. Dobbas's market. He opened Frey and Schmeder's Tiger Meat Market from a canvas tent after the fire of 1897 and sold it at a healthy profit within months. (Courtesy of El Dorado County Museum.)

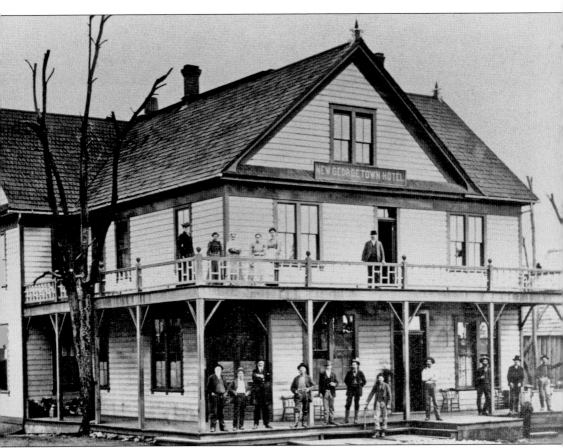

Swiss born Carlos "Charles" Forni had learned the hotel business in France but came to California to establish a stock and dairy farm. Returning to his training, he rented the Pioneer Hotel from B. F. Shepherd in 1887. He successfully operated it until the hotel was destroyed in the 1897 fire. Forni bought the lot where the vacant Georgetown Hotel had stood and erected the "new" Georgetown Hotel, pictured shortly after construction was completed by Frederick Schmeder. The two-story building, complete with basement, measured 80 feet by 100 feet and offered 30 rooms "elegantly furnished and supplied with all the modern conveniences." From left to right are (first level) John Pedrini, John Balderston, A. Parker, Alexander Francis, Frank Porter, unidentified, Charles F. Irish, Dick Reed, Bill Collins, George Roberts, and Joe Francis; (second level) Jean Sornberger, Ruth Vernon, Dora Crawford, Emily McCulloch, and owner Carlo Forni. The hotel went through a series of owners and different managers until 1921, when owner Walter Reinhardt closed the doors, leaving Georgetown with no hotels or restaurants for the first time in its history.

German native Henry Hakemoller mined at Sailor's Flat and Murderer's Bar for several years before purchasing a store on Irish Creek. The front room was a store and stage stop; the rear was living quarters. A robbery at the store, costing the life of a patron, distressed Hakemoller so much he closed down. He homesteaded 400 acres, farming and raising cattle. Modern-day Hackomiller Road runs through his ranch property. (Courtesy El Dorado County Museum.)

Susan Smith Poor and her husband, John, operated a small store and saloon near Georgetown. John had begun mining at Columbia Flat, where he found a very large cache of gold hidden by a Mr. Pierson, saving him much effort. Pierson had been killed in a robbery at Hakemoller's store. The store burned in 1880, but the Poors promptly rebuilt, as it was quite successful. (Courtesy El Dorado County Museum.)

After graduating from the University of Tennessee and Vanderbilt University of Medicine, Dr. William Simpson Hickman left Tennessee in 1886 and came west to practice medicine in a climate healthier for his asthmatic condition. A chance comment by a fellow train passenger brought him to Georgetown where he spent the rest of his life serving the sick and needy, often giving his service free of charge for those unable to pay him. He was the proverbial small-town doctor, offering every service from tooth extraction ($1) to delivering babies. A lifelong bachelor, he maintained an office, residence, and drugstore in a small frame house on Main Street, between the water company building and the armory. He was one of the most beloved residents of the community, taking an active part in all its affairs. His death at 66 was a blow. The day of his funeral, schools and businesses all closed to pay their respects to the country doctor. (Courtesy Georgetown Masonic Lodge No. 25)

Walter Gow Drysdale was a born publicist. He spent his years in Georgetown promoting the town and everything about it. He helped his wife, Amy Horn Drysdale, resurrect the *Georgetown Gazette* for a few years and then established the *Placerville Times* in 1936. The newspapers made a perfect venue for Drysdale to hone his public relations skills. He did some contracting and sold some real estate. He was a charter member and the first president of the Georgetown Divide Rotary Club, and its many projects were often his idea. He actively sought to bring medical care back to Georgetown after a 28-year lapse. He suggested and promoted the first Jeeper's Jamboree in 1953 and scattered pictures of the fledgling festivity all over California. The idea that Georgetown might have been called "Growlersburg" at one time, for the nuggets "growling" in the pan, was Drysdale's brainchild. Walt and Amy donated property to Georgetown to establish a city park. (Courtesy Georgetown Masonic Lodge No. 25.)

Emma (left) and Mabel LeBoeuf (right), their mother Emma, and their sister Esther threw themselves into their assigned roles as society leaders in Georgetown, taking starring roles in home talent shows, musical concerts, costume balls, and the like. Wife and daughters of the very successful and wealthy blacksmith Theophile LeBoeuf, they were never seen in public without being dressed in the most modern fashions and wearing elaborate hats of their own design.

The early ministry of the Reverend Charles Caleb Pierce reads like a road map of El Dorado County. He walked or rode a mule from one end of the county to the other. He officiated in over 1,300 burial services in more than 40 cemeteries. Noted for his compassion and service, he always refused remuneration, depending on goodwill for occasional meals and a place to sleep. (Courtesy El Dorado County Museum.)

Alexander T. Lee worked in a variety of mercantile establishments in Georgetown. In 1872, he moved slightly down the hill to Greenwood, where he became postmaster. Word that San Francisco capitalists were looking into developing quartz-mining properties in 1879 sparked a resurgence of activity. Other hotels in the area were not sufficient to meet all anticipated newcomers' needs, and Lee opened the American Exchange Hotel in the vacant Harry Moore Raymond hostelry. The hotel, just called Lee's, was a popular gathering place when the daily stage dropped off passengers and the mail. Lee's widow, Mary Ferguson Marson Lee, continued to maintain the hotel after his 1890 death, but the anticipated mining revival had not materialized and the hotel business fared poorly. Fire broke out in the building, and the structure burned to the ground in 1914.

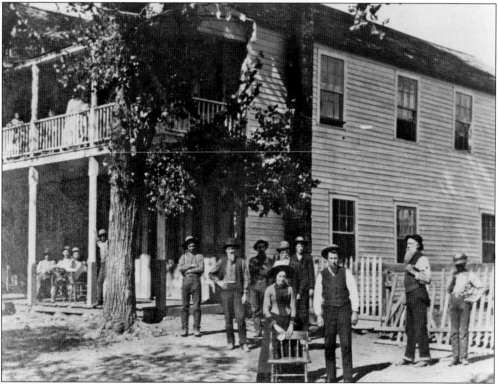

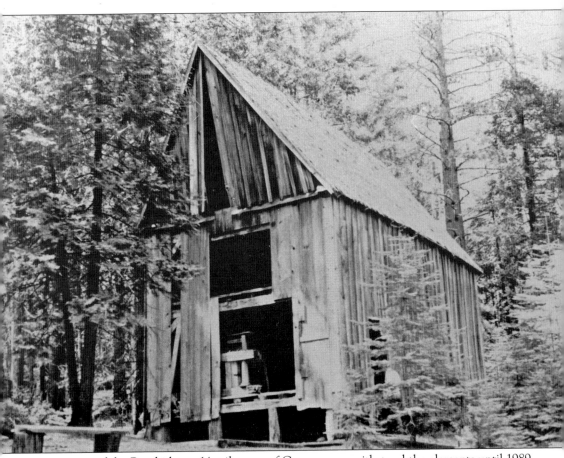

Remnants of the Bacchi barn, 14 miles east of Georgetown, withstood the elements until 1989. William Bacchi said the foothills of the Georgetown Divide reminded him of his former home in the Swiss Alps. He bought 17 cows and one bull in 1856, the beginning of a cattle dynasty. Taking advantage of cooler weather and longer-lasting water sources, he homesteaded land high on the Georgetown Divide for summer grazing and began the semiannual movement of cattle to and from the grazing area. Bacchi's son Henry became a cattle buyer and rancher and began to buy large tracts of rangeland, many of which are still owned by the family. He began to supply fresh beef to the logging camps springing up in the upper reaches of the Georgetown Divide, building a slaughterhouse and buying this barn, constructed by Mr. Merzo in 1889, to house the animals. In the early 1960s, the Bacchi family moved its summer operations to Oregon. Blodgett Forest Research Station has recreated the barn, salvaging the lumber and using the same construction techniques. (Courtesy Bob Heald.)

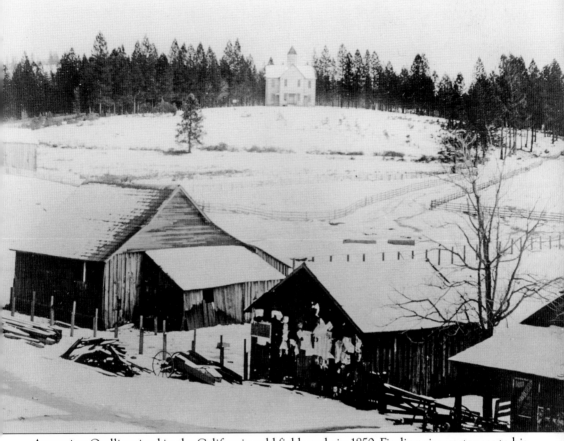

Augustino Orelli arrived in the California gold fields early in 1850. Finding circumstances to his liking and seeing many opportunities available, he made three trips back to his native Switzerland to spread the word, encourage immigration, and acquire a bride. Orelli first established a dairy farm in Forest Hill, moving to Georgetown and setting up several businesses. By 1875, he was operating a hotel in a two-story frame building on mid–Main Street, on the lot now occupied by the Georgetown Fire Department station house. He ran an undertaking parlor from the basement of this building. A first-class funeral could be arranged for $50. He also managed Orelli's livery stable (in the foreground of the photograph) across the street. The stable caught on fire several times in the 1897 fire but escaped with little damage. The hotel and undertaking parlor were completely destroyed. Orelli retired, leaving his son to move the undertaking business to Placerville. Orelli's livery stable building was remodeled into the Forget-Me-Not Garage in 1927.

Wentworth Springs Road, pictured 14 miles east of Georgetown in 1941, is named for Nathan Wentworth. Wentworth tried his hand at several occupations, including mining, farming, butchering, and some teaming work as well as working at a sawmill, before stumbling across some mineral hot springs 22 miles east of Georgetown while hunting in 1879. He immediately saw an opportunity, christened the springs with his name, and set about establishing a resort. He advertised the mineral waters for health and pleasure, sold soda water in kegs or bottles, and offered fine dining at the hotel built on-site. The resort was a great success. Wentworth died at the resort in 1884. Family continued operations until selling to Robert S. Jerrett around 1900. Jerrett and his wife operated the resort until they sold the property and the Jerrett ranch near Georgetown to actor Lon Chaney Jr. in 1944. The Wentworth Springs Hotel stood empty until snow collapsed it in 1980.

Five

THE COMFORTS OF HOME

Even the hardest working miner needed an occasional rest from the backbreaking work. In the early gold camps, fraternal organizations provided a safe and welcome environment. The arrival of women and children spurred the formation of even more social amenities, adding churches and schools. Repeated fires discouraged many of the groups, but others maintained and rebuilt.

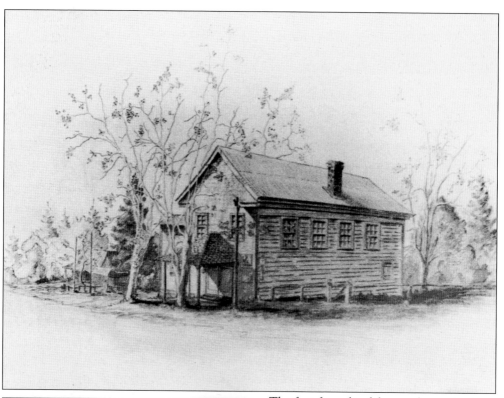

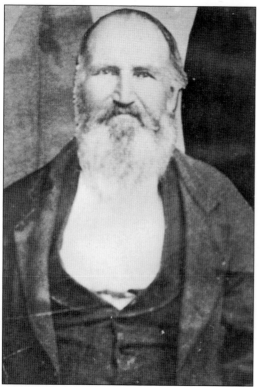

The first formalized fraternal organization in Georgetown was Georgetown Lodge No. 25, Free and Accepted Masons. Its first lodge burned in 1852. The new lodge, built in 1855, shown above in the pencil sketch by Roy German, was lost in a fire on July 27, 1948. The only lodge possessions saved were the highly prized silver regalia and jewels, not in the building at the time. John Paul Jones Davidson, a charter member, sailed as a midshipman on the USS *Constitution* ("Old Ironsides"), served as warrant officer in the War of 1812, and was with Admiral Perry at the Battle of Lake Erie. A volunteer captain with the Mexican Navy, he switched sides to the U.S. Navy when war broke out. He retired to Georgetown from Mare Island Naval Shipyard (MINS) during the Gold Rush. (Both courtesy Georgetown Masonic Lodge No. 25.)

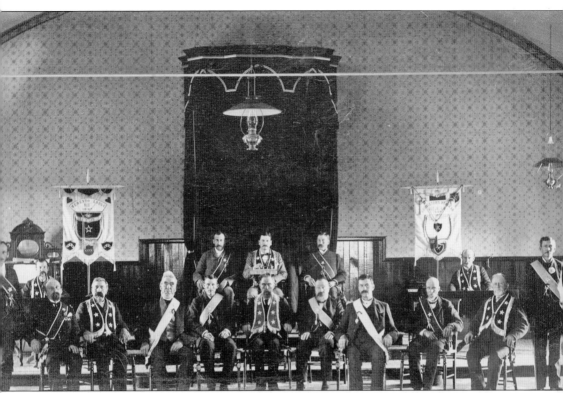

The IOOF was well represented among the miners, and they naturally gravitated toward each other. Momento Lodge No. 37 was organized at a meeting on March 25, 1855. By 1881, total membership stood at 36 members. Pictured from left to right are (first row) Fred Schmeder, Charles Forni, Alex Francis, Dan Craig, Joe Swift, Charles Wentworth, Gus Orelli Sr., Orin Scripture, Thomas Armstrong, Dan Jerrett, and Robert Murdock; (second row) Charles Irish, George Heuser, William Hickman, Ben Currier, and Charles Langley. Their major goal is relief of the distressed, but Odd Fellows take burying the dead very seriously and selected a plot within the northwest end of Georgetown Cemetery in 1862 for their use. The section was dedicated July 22, 1864, and is still used and maintained by the lodge. Grave markers of Odd Fellow members are usually identified with the organization's symbolic three rings looped together, standing for friendship, love, and truth. This symbol is on Isaac Green's marker, the oldest headstone in the Georgetown Cemetery.

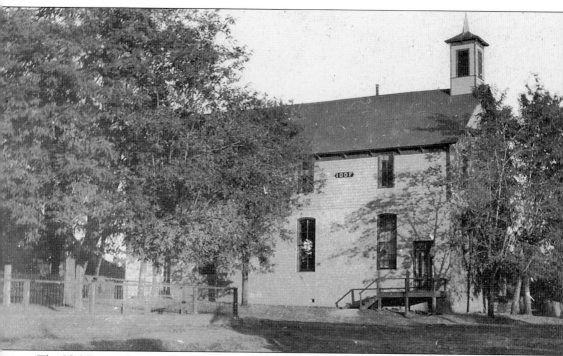

The IOOF moved to purchase the larger Whiteside building, also known as the Balsar House, in 1878. The building was then a single-story structure occupied by Sornberger and Lane's general mercantile. Remodeling did not actually begin until 1888. Fred Schmeder was awarded the construction contract and added a second story to fabricate a large meeting hall for the lodge, leaving the lower story available for public use. Because of its size, almost all funerals were conducted from this centrally located building. To announce the procession leaving for a funeral, someone would ascend to the tower atop the building and toll the bell. The first meeting of the IOOF brotherhood in the new hall took place on January 19, 1889, although formal dedication was delayed until November to allow dignitaries to be present. The Odd Fellows continue to meet in the hall, and the public continues to rent the lower rooms for events.

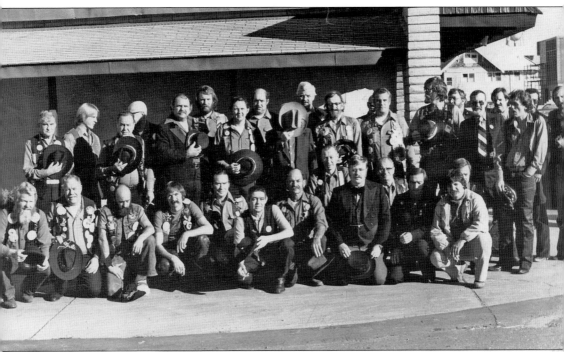

E Clampsus Vitus, an organization that took pride in not taking itself too seriously, organized in Georgetown in 1855. Clearly a lampoon of other active secret societies, Clampers thoroughly enjoyed the ridiculous, had a marvelous time, and were actually very good citizens, often quietly proceeding to take care of "widders and orphans" when necessary. Georgetown's Clamper chapter folded within 20 years to be reorganized as Growlersburg Chapter No. 86 in May 1973. Pictured are Growlersburg Clampers at the funeral services of fellow Clamper Dick Kieffer around 1980. From left to right are (first row, kneeling) Jim Fulling, unidentified, Marv Watson, Earl Gurnsey, Pat Patterson, unidentified, Archie Liddicoat, two unidentified, Bill Butts, Richard Daniels, Bob Jiles, and unidentified; (second row, standing) "Miner" Bob, Doug Stigen, Eddie Hanson, Duane Stigen, Ron Lera Sr., Larry Anderson, Ron Crone, two unidentified, Grant Frame, Robbie VanVooren, Butch Wylie, three unidentified, Clicker Slocum, Chip Gash, two unidentified, and Bob Renier.

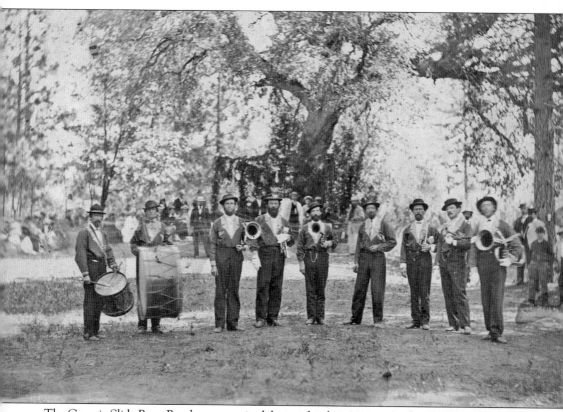

The Georgia Slide Brass Band was organized during the slow winter months of 1875–1876 by Joseph Reinhardt. Its first public appearance was at the wedding of James Flynn to Maggie Morgan. They were such a hit their appearances extended to dances, parades, parties, and multiple ceremonies. The youngest member of the original band was John Flynn. At an early age, when the band practiced next door, he played along on an old oilcan—two to three beats behind the band. In self-defense, band members invited him to join them and taught him to play the snare drums and later a trombone. The band played all along the Georgetown Divide until around 1900, when old age finally claimed most of the members. The name has been resurrected several times over the years for bands formed featuring brass instruments. The photograph, taken in 1870 at the Maywood Picnic Grounds below Main Street, features band members, from left to right, Johnny Walla, Billy Pickens, Mr. Bryant, Mr. McGonigle, unidentified, Ben Shepherd, band organizer Joseph Reinhardt, Fred Cricky, and Mr. Daner.

By 1853, there was an official Catholic parish in Georgetown. The pioneer church, constructed at the northeast corner of Church and Placer Streets, burned in 1858 and was promptly rebuilt but succumbed to fire again in 1869. The very small congregation met in private homes or social halls until the old armory building was converted for use in 1881. In 1923, a new church was constructed on Main Street. Pictured at right in 1963, the church was entirely free of debt a year later, primarily due to generous donations. The church was used until 1980, when a new, larger church was built south of Georgetown Elementary School. The old building was purchased by Mark Smith and moved to a hill alongside the Buffalo Hill Shopping Center to be used as a museum. The old church is pictured with a brand-new paint job, ready for occupancy (below).

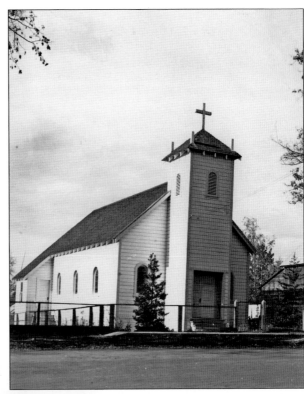

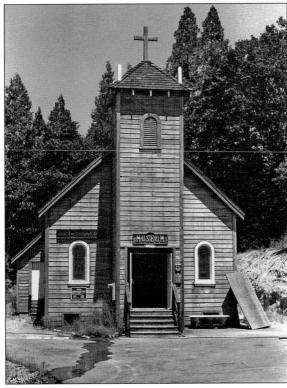

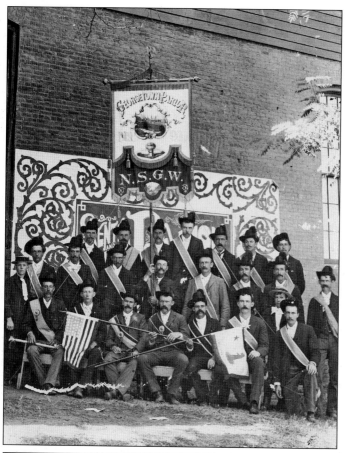

Some organizations were unique, basing their beginnings on the Western experience. The name said it all for the Native Sons of the Golden West founded in 1875 to promote California's early history. Native Sons members have long been active in the preservation of icons like Sutter's Fort, and the group is responsible for many of the historical markers found around the state. To belong, the member must have been born in California. Should an active member fall ill, the local Native Sons' Parlor helped pay expenses, an early form of disability benefits. Early members were required to pass physical examinations before joining. Georgetown's Parlor No. 91, organized on August 27, 1886, still has its original regalia, brought out now only for ceremonial occasions.

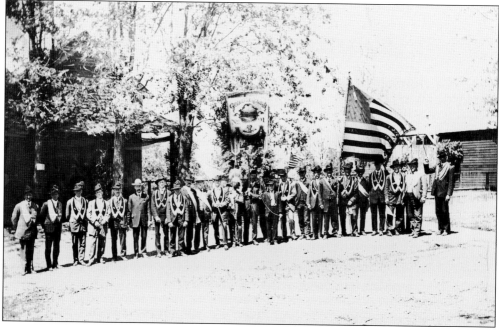

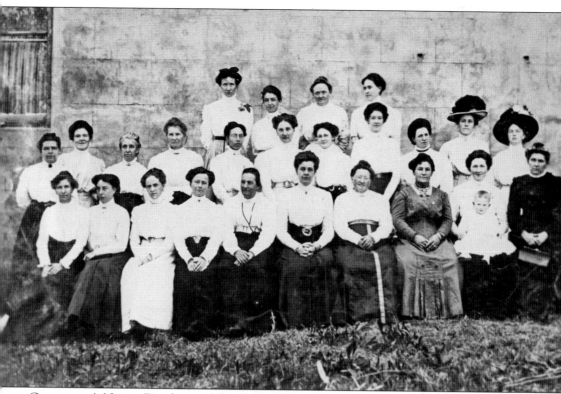

Georgetown's Native Daughters of the Golden West, the Native Sons' counterpart, officially organized on May 16, 1910, as El Dorado Parlor No. 186. Irene Irish was the parlor's first president. The group originally met on the second floor of the IOOF hall, but continuing construction noise drove them to look for alternative meeting places in 1968. Native Daughters' projects focus on the preservation and dissemination of the history of California. Toward this end, its members focus on erecting historical markers in appropriate places. Although still active, membership is dwindling, and they are considering consolidation. From left to right are (first row) Elizabeth Buchler Irish, Mary Norris, Clara Bauer, Lena Caprara, Hattie Heindel, Emma Lou Humphery, Mary Thorson, Ida Baker, Ethel Francis, and Irene Irish; (second row) Mrs. T. Kelly, Deila Stanley, Edith Hume, Ida Childress, Anne Thorson Heindel, unidentified, Maude Horn, Maggie Smith, Dora Wood, Lena Buchler, and Elizabeth Murdock; (third row) Metta Buchler, Addie Vernon, Maggie Roberts, and Clara Rupley.

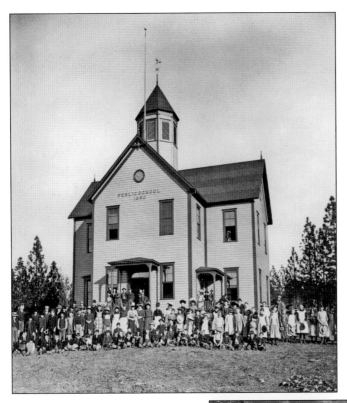

History of area schools was also the story of the communities—the need for many schools to serve a rapidly growing population gradually leveling off and beginning a slow decline as the population dwindled. Better transportation and the impracticalities of supporting multiple school facilities eventually caused the few small schools that remained to consolidate, first into two grammar school districts: Georgetown and Cool's Northside Districts. (Courtesy California State Library.)

Originally constructed at the corner of Church and Placer Streets in 1889, the Methodist church building is shown two years after the church was dismantled from its foundation and carefully hauled to its present location on the south end of Church Street. Two new lots were purchased, and the entire church was moved on August 18, 1961. It continues to serve the Methodist congregation.

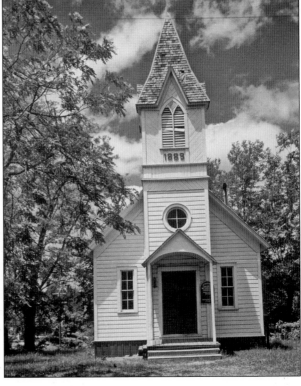

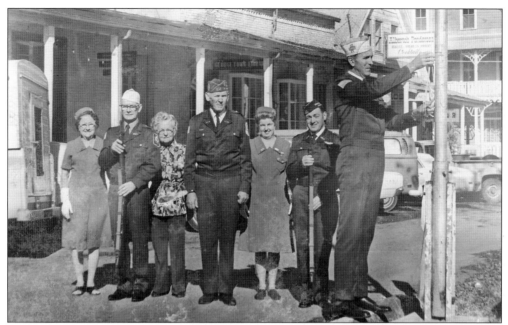

Veterans of Foreign Wars (VFW) Growlersburg Post No. 9241 was formed on April 12, 1947. VFW purchased the old butcher shop from Sartor Francis's widow in 1952; the building is still in use. In 1986, new land at Eaton Road was purchased for VFW use and development. Pictured at the raising of the flag are, from left to right, Amy Clifton, Earl Helvy, Mabel Helvy, Charlie Wilkinson, Audrey Butts, Jose Gleason, and Martin Zdolsek.

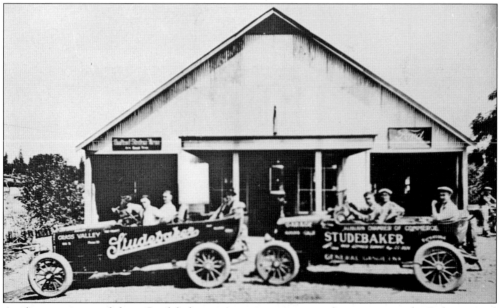

As the passengers of these Studebaker touring cars preparing for a trip over the Rubicon trail indicate, tourism and recreation are not a new idea for Georgetown. Beginning with the lavish Rubicon Springs Hotel, Georgetown has been the gateway for travelers looking to get away from it all and into the uncivilized backcountry. Wentworth Springs Road was passable to Lake Tahoe by passenger automobile until 1943.

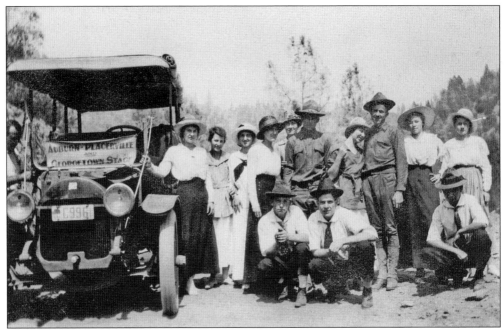

One of the biggest impacts on Georgetown was the introduction of the automobile. Individual automobiles began to appear on the Georgetown Divide as early as 1905, but it took a few more years for the new fad to catch on. Originally only the wealthy such as A. J. Macey, owner of both the Georgetown Hotel and the American Hotel in 1910, could afford one. Katherine Falsgraft Buchler and Frank Jefford pose in a 1912 touring car below. C. J. Rupley kicked off introduction of the automobile to his established stage lines with the posed photograph above of his drivers and their spouses in 1914 alongside one of his new Buick autos. Rupley phased out his stage business, the only stage operation in Georgetown, entirely within a few years. By 1915, there were only 165 automobiles in the entirety of El Dorado County.

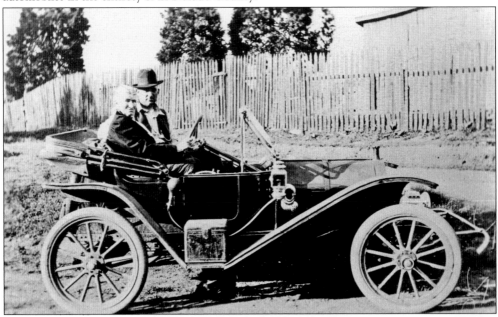

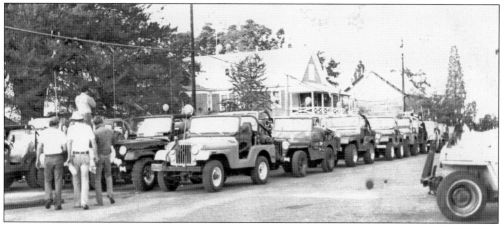

Georgetown Divide Rotary Club was founded on March 22, 1948, largely through the efforts of first president Walter G. Drysdale. Rotarians hosted the first commercial trans-Sierra Jeep trek and the Jeepers Jamboree, devising to boost the local economy. The first Jeepers Jamboree left town in August 1953 with 55 vehicles and 156 participants. When this photograph of Jeeps lined up on Main Street was taken in 1974, participants were spending almost $200,000 in El Dorado County annually.

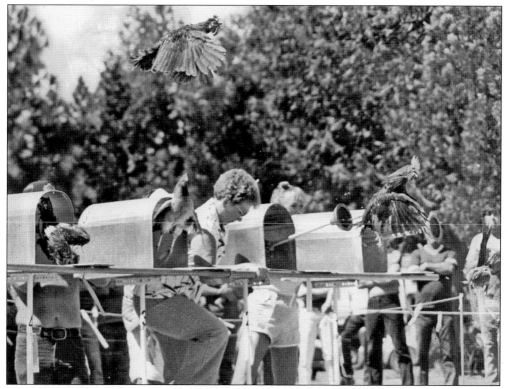

This photograph, taken in 1984, was part of the zany Chicken Fly-Off, performed with mailboxes and live chickens at Georgetown Airport. Chickens, loaded into specially prepared metal mailboxes, were boosted into flight with toilet plungers. The owner of the chicken that flew the farthest won the prize money. An air show and aircraft demonstrations capped the proceedings. This bit of silliness was sponsored for several years by the Divide Business Association.

Georgetown Rebekah Lodge No. 64 was instituted on August 4, 1881. Charter members were S. J. Titus, Freruque Nagler, H. M. Dains, Florenda Nagel, Mrs. A. R. Schlein, Henry Jones, C. F. Irish, Mrs. H. M. Dains, Mrs. R. Bundshuh, Theodore Schlein, A. A. Francis, Godfrey Schmeder, T. F. Armstrong, Mrs. M. Leutsinger, Mrs. W. Davey, W. Davey, Hattie Schmeder, Anne Craig, T. Hotchkiss, Francis Orelli, and A. J. Wilton. Pictured in the 1974 photograph are, from left to right, Rebekah Lodge No. 64 members Margaret Douglas Chamberlin Jones, unidentified, Delma Elliott, and student Jennifer Borello waiting for a program to begin. The Rebekahs continue to meet in the IOOF lodge hall, pictured here in 1970.

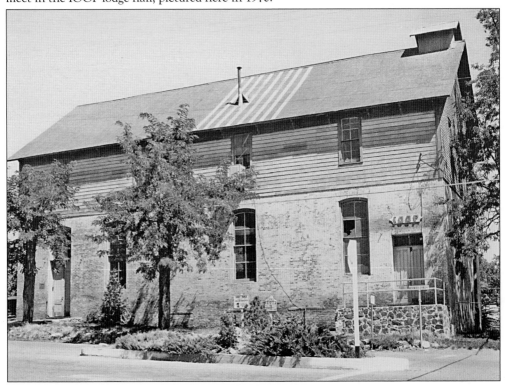

Six

OUR TOWN'S AFIRE!

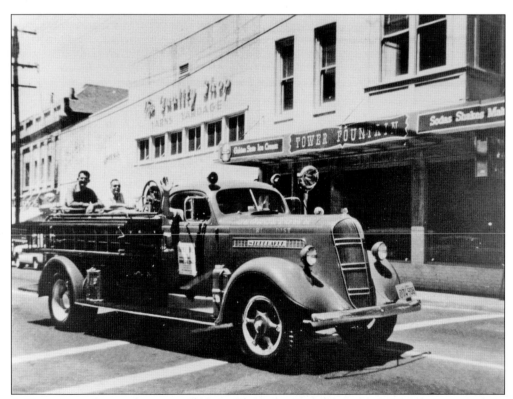

A Georgetown fire truck, not available in Georgetown's early years, participates in a parade in 1962. Early building materials consisted of canvas or wooden planks—relatively inexpensive and available, but highly flammable. Fire damage was an ever-present threat. The first town site was reduced to cinders when an accident with a photographic light set the entire town afire July 14, 1952.

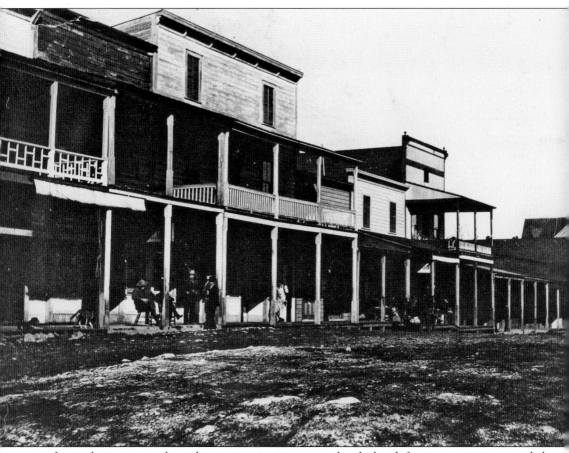

It was obvious very early on that an organization prepared to deal with fire emergencies was needed. The Mountaineer Hook and Ladder Company was organized in 1854. Manned by volunteers, newly acquired Engine No. 1 led Georgetown's 1856 Fourth of July parade. A mere three days later, they were called into action when a rapidly expanding fire was reported in the business block. The fire department responded quickly, but flames spread unabated. Rising winds defeated architectural planning and jumped the extra-wide streets anyway. Unable to stop the destruction, firefighters abandoned their apparatus when burning walls collapsed on it. Church Street was saved when the town's women stood in the Georgetown Ditch, running along the street dipping up water to pass to men coming in from the claims to assist. Only the town hall on the upper end of Main Street and Shannon Knox's house on the lower end were saved. Citizens pitched in and rebuilt, only to face another major conflagration on August 16, 1858. This time firefighters stopped the fire before it reached all the cross streets. Pictured around 1866 is Georgetown rebuilt.

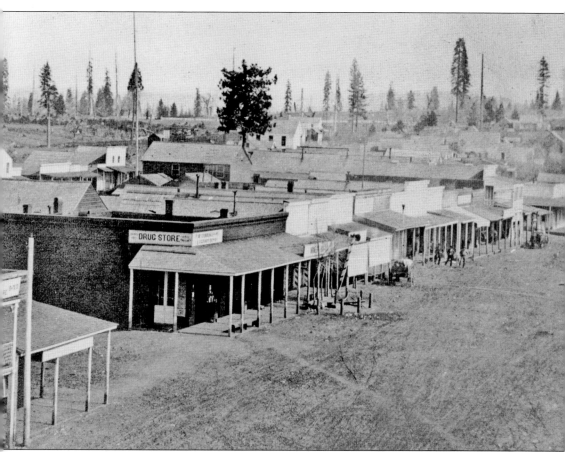

Although consuming several structures in the main business block, a blaze on April 19, 1859, was controlled fairly quickly. Remarkably there were no fire-related injuries or deaths until flames originated inside the Miners Hotel on mid–Main Street the night of May 28, 1869. By the time aid was summoned, the fire was well underway and spreading. The hotel proprietor, Mr. Stahlman, was blamed for the fire and for the deaths of his wife, three children, and a mother's helper, all locked inside the hotel. A number of merchants rebuilt with locally manufactured fireproof brick, expecting the thick walls to withstand fire far better than wooden-frame structures. This c. 1872 photograph shows the drugstore's solid brick walls. Huge iron doors, installed to be closed tightly in case of fire, were set into the buildings. The new design worked well for a bit. Only two fires, small by comparison, were recorded: one in March 1873 that primarily involved the Chinese settlement on the flat below Main Street and one in May 1889 that was contained on the southern side of Main Street.

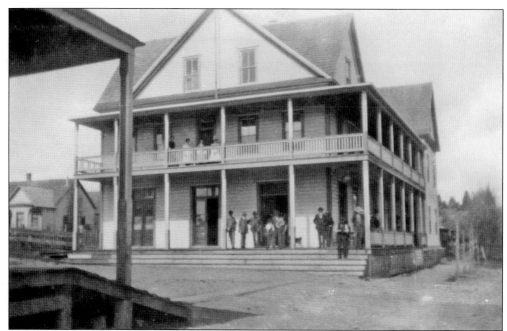

In 1890, a small fire started in a bedroom of the American Hotel, burning into the roof and destroying the bed before an adjacent roomer smelled the smoke and turned in an alarm. The roomer did not wait for firefighters and, according to the report in the *Georgetown Gazette*, "splashed one dash of water and successfully checked the flames," averting disaster just before the fire would have been out of control. Sparks from the 1897 fire spread to the hotel three times, but were extinguished each time. The hotel's luck ran out on April 6, 1899, when a blaze erupted from one of the chimneys, igniting the roof and soon engulfing the entire structure, completely gutting it. Hotel owner Mary Bundshuh hired contractor Fred Schmeder to begin immediate construction of a new hotel, shown in the photograph above shortly after rebuilding was complete. The landmark hotel is missing in the below photograph taken from the schoolhouse just after the 1899 fire.

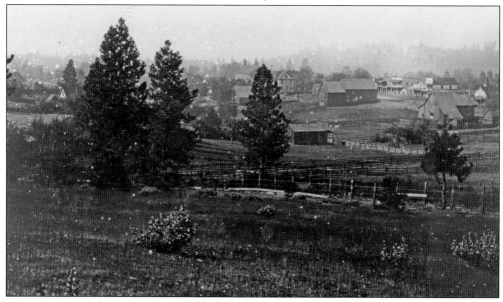

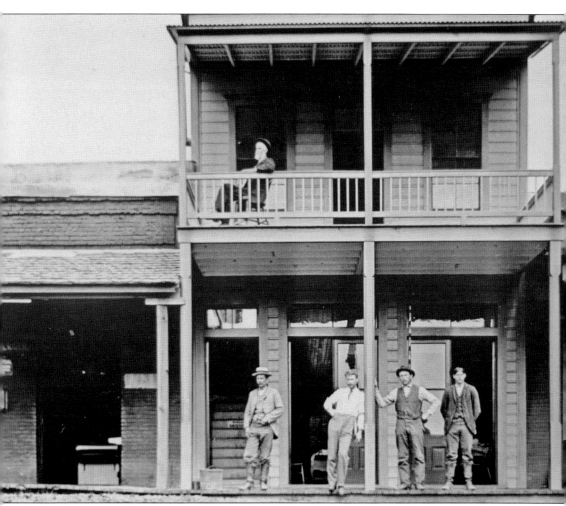

The central portion of Georgetown's business is seen here in this *c.* 1896 image. Dentist John Franklin Farnsworth is sitting on the balcony of Fred Schmeder's building. Standing below are, from left to right, Andy Kenney, barber Joe Ward, Schmeder, and Charlie Adams. The brick enclosed mercantile belonging to Harmon Sornberger is at left in the photograph; I. P. Jackson's brick structure is seen off to the right. A faulty flue in the Tahoe Saloon on the northwestern end of the block set off a chimney fire on June 14, 1897, which spread through the building before it could be contained, then subsequently moved in both directions. Flames were being whipped by a strong south wind, and frame buildings quickly burnt to the ground, adding more embers and smoke to the air. The brick construction appeared to be retarding damage; the Shepherd store, Sornberger's, and Jackson's sustained only minor damage although all the frame buildings between them burned. Unfortunately, burning debris was discovered on the interior of the Jackson store.

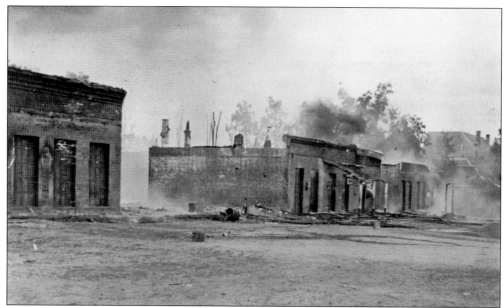

Flames from the Jackson building spread across the rooftops, finally reaching the top of Sornberger store. Eventually that roof caught fire, and burning debris began to drop into the interior. Sornberger specialized in miners' supplies, including a sizable cache of dynamite kept in cool storage below the main floor. At 2:15 p.m., a terrific explosion gave ample proof that fire had reached the dynamite storage. Smoke and dust obscured daylight; glass, brick, burning timbers, and all manner of debris began to fall on the town. Two heavy iron security doors were thrown over 100 feet. The brick buildings designed to protect the contents actually hampered firefighters. Burning debris was carried across the street, wiping out the Georgetown Hotel, charring portions of Orelli's livery stable, and burning or heavily damaging any buildings standing before the explosion. One person died, and there were numerous injuries reported.

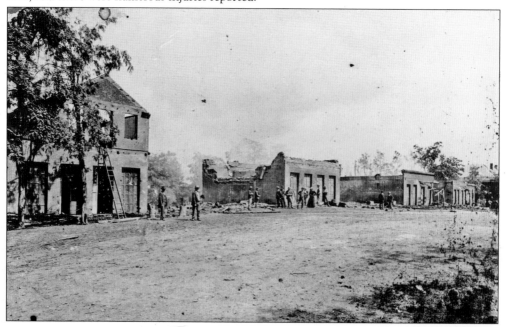

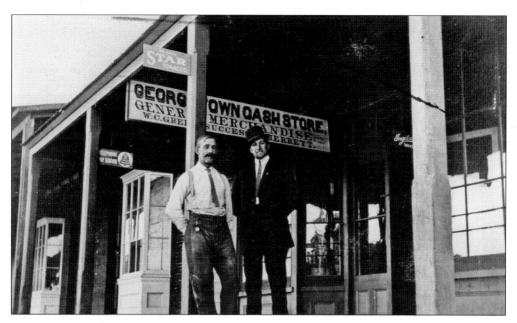

It took two years to clean and rebuild the town after the disastrous fire in 1897. The fire department had once again lost most of its equipment. Bits of burnt debris from the disaster occasionally continued to surface for over 35 years. The first building to go up after the fire was Alexander Francis's two-story butcher shop. B. F. Shepherd began to rebuild on the corner of Main and Placer Streets, and Daniel Jerrett started a frame building on the site of his old store across from the American Hotel. Sarah Jackson built the Georgetown Cash Store, pictured above with two unidentified men in front, on the site of her burned structure. Carlos Forni purchased the lot where the burned Georgetown Hotel had stood and built the New Georgetown Hotel (below) on the same spot, opening for business by December.

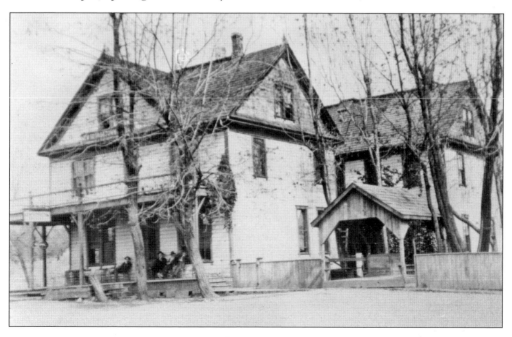

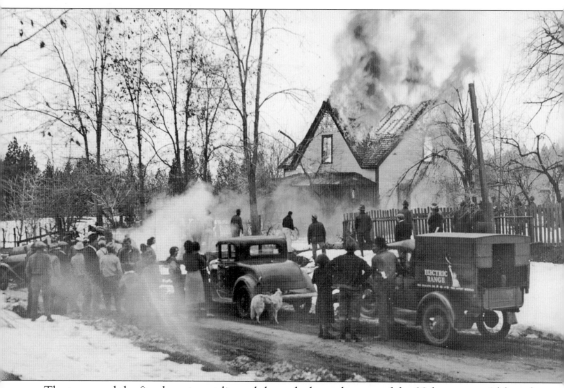

The town and the fire department limped through the early years of the 20th century. Although there was never a lack of response to a call for help, as virtually every man working or living within sound range of the alarm bell would answer, the fire department lacked firm organization and often depended on equipment and manpower assistance from the U.S. Forest Service or Pino Grande Mill personnel. Georgetown fire volunteers took steps to revitalize the fire department in May 1927, electing Clarence S. Collins as fire chief and renaming the department the Georgetown Fire Department. Placerville Fire Department generously donated an old Lincoln fire truck, a "Locomobile," to Georgetown. Funds raised through community donations were put to use to purchase additional fire hose and equipment and to build a structure to house the engine on property owned by the Georgetown Divide Water Company. It was also decided the department would consist of 25 active members, officially dressed in white shirts, red suspenders, and black bow ties.

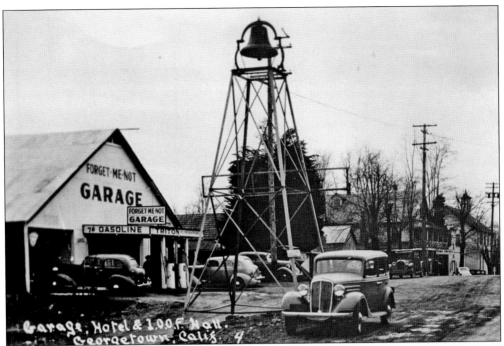

Garage, Hotel & I.O.O.F. Hall.
Georgetown, Calif. 4

After the IOOF bought the Balsar House in 1881, the bottom story served as a public hall and funeral parlor. A tower containing a bell was built at the roof peak. A man in the tower would start tolling the bell when a funeral procession started at the home of the deceased. The centrally located bell was an excellent way to summon the fire department as well, as the large bell could be heard for several miles. Unfortunately a Pentecostal minister also began to use the bell to collect his congregation. Firefighters were annoyed, the general populace was confused, and as the bell tower was beginning to disintegrate, the bell was taken down in 1930 and hung from a steel tower in the center of Main Street.

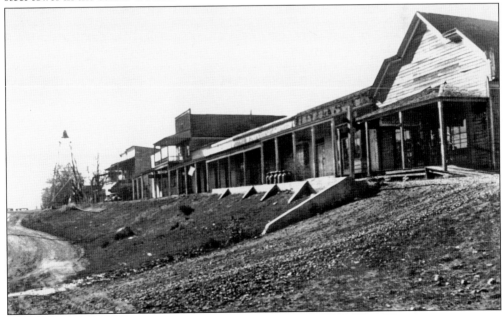

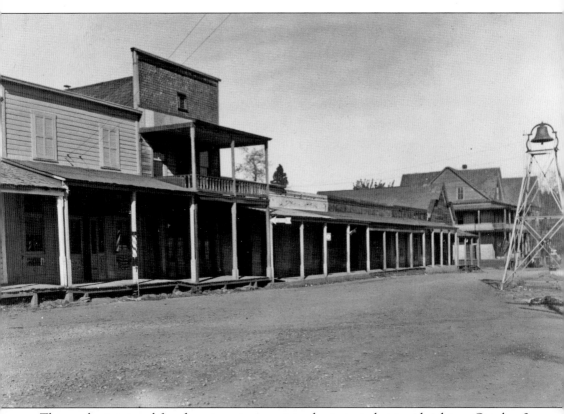

The newly structured fire department was put to the test at about midnight on October 2, 1934, when a fire broke out, originating in McCullough's liquor store located at far left in this 1933 photograph. The blaze swept out of control and began to spread. Georgetown firefighters hurried to put their equipment into play, but the Locomobile lacked a self-starter, requiring a tow to start the engine, and was not immediately ready for use. A U.S. Forest Service portable pump was dropped into Georgetown Ditch and supplied the first high-pressure water on the fire. The fire engine from the Pino Grande Mill arrived almost simultaneously with the starting of the Georgetown fire truck engine. Firefighters held the blaze at the Miner's Club, preventing it from spreading to the end of the block, but flames reached buildings behind the main business block, including two residences and the county garage. Fire engines and crews from Placerville, Camino, and Auburn also showed up to assist. Once sufficient water was available, the fire was finally doused, but not in time to prevent damage in excess of $100,000.

The 1934 fire nearly wiped out prosperous businessman Jerome C. Ackley. The store he owned at Shepherd's Corner had withstood three disastrous fires after being constructed of brick by B. F. Shepherd. Ackley's businesses were not so lucky in 1934. The building shown before and after the fire was one of three commercial enterprises Ackley and his wife owned. Their two-story residence was in the rear at the corner of Placer Street and Maiden Lane. After the fire, this Ackley building was still sound, but the merchandise was badly damaged. His residence was destroyed with all contents, as was a second house he rented out. Water had heavily damaged his warehouse. Ackley carried only minimal insurance on his home and nothing on the other structures. He rebuilt but elected in 1939 to sell his holdings and move away.

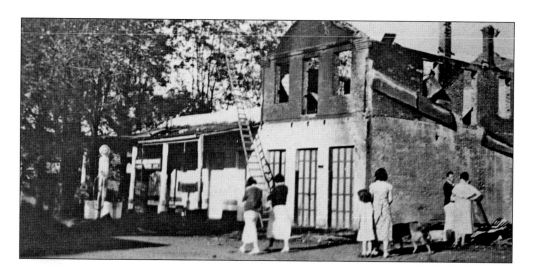

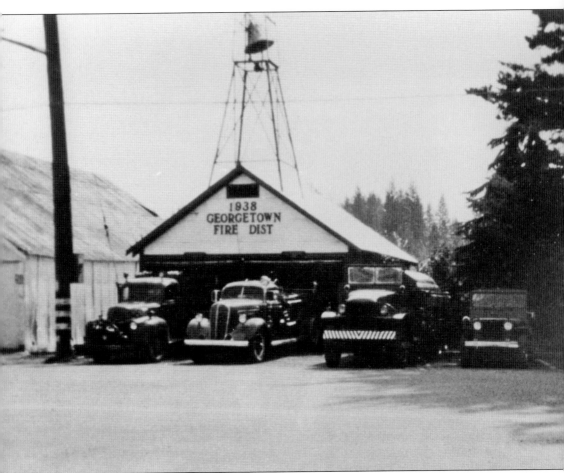

Georgetown had been considering the purchase of a new fire engine, and the devastating losses in the 1934 fire solidified that resolve. In July 1937, a ballot measure to officially form a Fire Protection District was enthusiastically adopted by voters. The first item of business was the purchase of a brand-new 1937 Studebaker fire truck. That truck is still owned by the department and has been lovingly restored. The second major item of business was housing the department's equipment. The water company building in use was no longer available, so a contract was awarded to William Breedlove and Charles Ganow to construct a new firehouse on Main Street, completed in 1938 and pictured here. The old fire bell was moved from the middle of Main Street and mounted on the firehouse. The district also purchased the old high school building on Church Street for $50 and christened it "Firemen's Hall," making it available to the community for meetings, dances, and socials for a number of years.

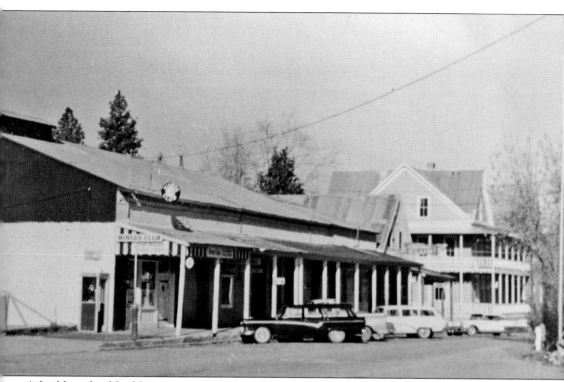

A building fund had been set aside for years to construct a first-rate firehouse with adequate space for all the department's needs. In 1965, the district felt sufficient funds were available and a lot on Main Street was purchased, plans were drawn, and construction was begun on the firehouse still occupied by the department. The new firehouse was to be between the Miner's Club and Maxine's Variety Store, at far left of this photograph. Much of the materials used and a significant portion of the labor for the firehouse were donated. All the volunteers and many community members pitched in to help in construction. The new firehouse was dedicated on May 20, 1967, and occupied the following year. When the current fire station was completed, the fire bell moved again to its present location atop the brick wall next to the station, its clapper permanently silenced. The Miner's Club expanded slightly, adding a storefront between the fire station and the bar. This structure was later converted to fire district offices.

On the extremely cold morning of December 13, 1968, Lou Allen attempted to thaw his frozen bathroom pipes with a blowtorch and set off a small fire. Unfortunately that was only the first of many skirmishes on one of the department's busiest days in 32 years, as 14 alarms sounded throughout the day for emergencies from chimney fires to downed power poles. At 2:30 a.m. the next morning, weary firefighters were called to a house fire at the DeBerry home on upper Main Street. A downed power pole had ignited the roof. The blaze spread to the Coonrod house next door, and suddenly both houses were aflame. Ice, freezing temperatures, and howling winds hampered firefighters. Water turned to ice, pumps froze, and fire hoses split, but firefighters kept the fire contained. The pictured Texaco gasoline station in the center of town went up in a spectacular ball of flame in 1984 when an errant spark from a fuel truck ignited the fuel-saturated floorboards of the old structure. Georgetown fire personnel rose to the occasion and kept the flames contained.

Seven

PURSUING ANOTHER BOUNTY

Early settlers in the Georgetown area described the towering sugar pines and huge Douglas fir trees that stretched as far as the eye could see. As mining declined, lumbering steadily grew in importance. For perspective, note the man standing at lower left in the photograph at the base of a sugar pine stand of trees. (Courtesy Michigan-California Lumber Company.)

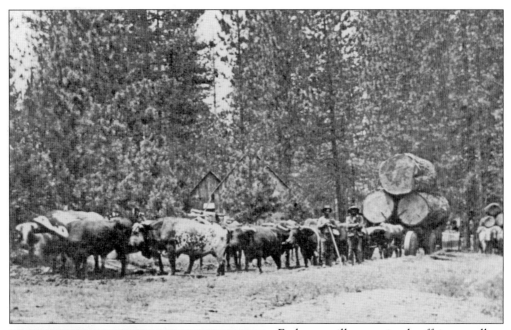

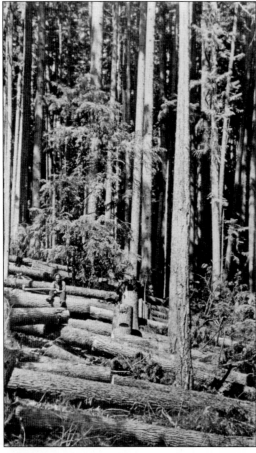

Early sawmills were simple affairs, usually located as close as possible to the source of the lumber. Steam drove the mill saws, trees were felled by human muscle power, and motive power was provided by ox teams, similar to the teams pictured here—frequently 12 animals yoked two abreast. Oxen, capable of pulling much heavier loads than either horses or mules, pulled a log wagon with solid–sugar pine wheels that were 14 inches thick at the hub and 7 inches at the tire. Each wagon was capable of sustaining a load of 20 tons. The first loggers into the Georgetown area were in awe of the huge trees they saw. Some were over 100 feet tall and 2 to 3 feet in diameter. (Both courtesy Michigan-California Lumber Company.)

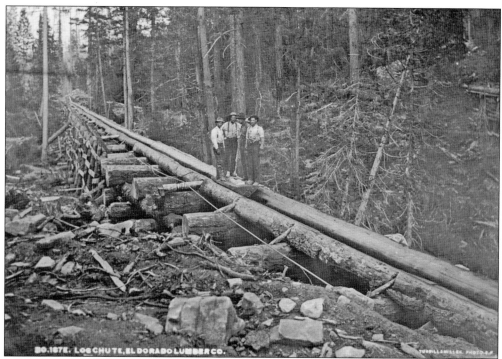

NO.187E. LOG CHUTE, EL DORADO LUMBER CO. TURRILL&MILLER. PHOTO.S.F.

These men above working for El Dorado Lumber Company around 1904 are standing on a "chute boat" riding the skids. The chute boat was a hollowed-out log used to convey the chokers, chains, and other equipment back to the logging area. Loggers often lived in logging camps set up near where the main logging activity was taking place. Mess halls, with company-paid cooks and bunkhouses, were home. A logger worked sunup to sundown, six days a week. The camps were simple affairs, named in sequence (Camp 2, Camp 3, etc.) or for a nearby feature that stood out (Gaddis Creek Camp). The logging camp photograph below taken in June 1898 does not identify the camp. (Both courtesy Michigan-California Lumber Company.)

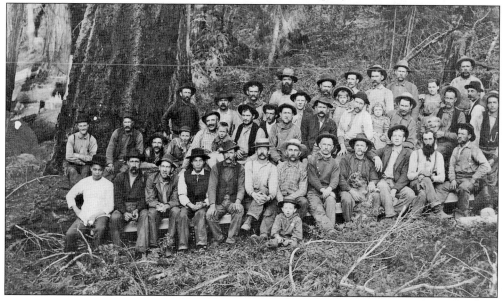

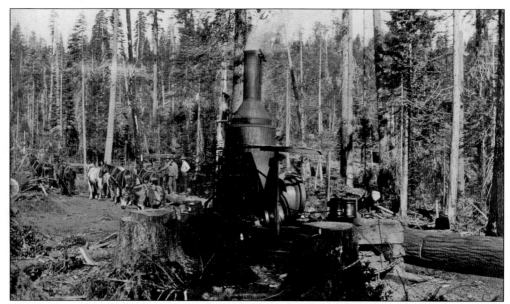

Harnessing steam made an incredible difference in logging. Loggers could pull logs from the woods with small powerful steam engines called Dolbeer donkey engines, named for their inventor and the animals they replaced. A spool, called a "gypsy," winched in a cable tied to a log. Communication between the man running the donkey and the logging foreman in the woods was done by the "whistle punk" who followed the logging crew into the woods dragging a light line tied to a whistle on the donkey. When the log was ready, the punk blew the whistle in a system of signals indicating which action was to be taken. In a rare moment of inactivity during logging season, three unidentified loggers pose below in front of log sections cleaned, cut, and ready to be moved to a landing (staging area) before loading for mill delivery. (Both courtesy Michigan-California Lumber Company.)

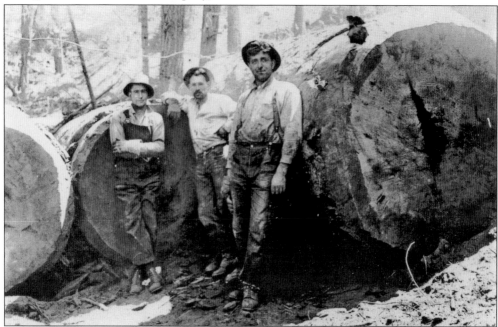

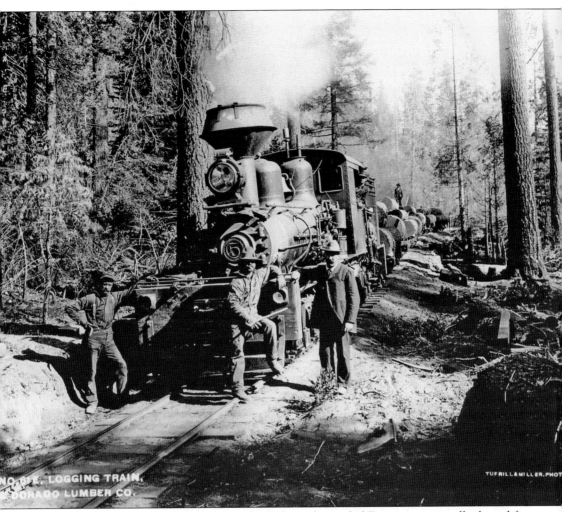

Powerful steam locomotives, long in use throughout the settled East, were not well adapted for working on the uneven and sloping ground in the forests that held the trees destined for market. A Michigan logger, Ephraim Shay, resolved the problem in 1881 by designing a small locomotive driven by worm gears instead of the larger exposed connecting rods in use. The first locomotive associated with Georgetown was delivered to American River Land and Lumber Company in 1891, traveling through trackless Georgetown on wagons, bells ringing to announce its arrival. Twelve miles of rail was laid through the trees to reach a central log collection point. As logging operations expanded under new owners, more track line was put in, often pulling an older no-longer-necessary railway to build a new line. This logging train, pulled by a Shay engine, has stopped for a photograph opportunity on what is now Mutton Creek Road on the eastern edge of Blodgett Forest Research Station. (Courtesy Michigan-California Lumber Company.)

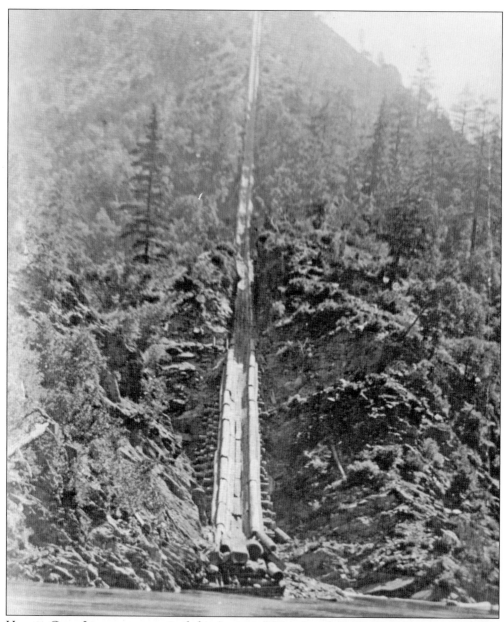

Horatio Gates Livermore organized the American River Land and Lumber Company in 1889, buying timberland east of Georgetown. He planned to float cut logs down the South Fork of the American River. A long chute was built, dropping more than 1,100 vertical feet from a ridge into the river. It took a 30-foot sugar pine log only 30 seconds to "smoke" its way down the chute. Unfortunately for Livermore's plans, the river was too rocky, too swift, and the water flow too unpredictable. Even after improvements in the river bed below were made, the plan was not workable. Logs piled up in places they were not intended to be left or shattered on contact with the river bottom. Three times a log boom designed to hold logs in place broke, allowing the timber to sweep downriver. A break on March 15, 1899, scattered at least 3 million board feet downriver as far as Rio Vista. American River Land and Lumber Company went bankrupt, selling or pledging everything. (Courtesy Michigan-California Lumber Company.)

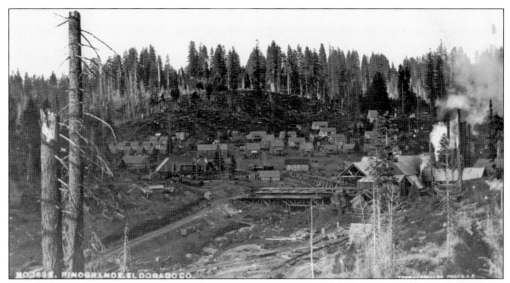

El Dorado Lumber Company organized in 1900 and began to build a large sawmill at a small mining camp known as Pino Grande (Big Pine). Lumber for this mill was produced by the Barklage Mill on Bacon Creek, a mill made obsolete by the larger, more efficient Pino Grande within a year. (Courtesy Michigan-California Lumber Company.)

Even though the tough little Shay engines were quite maneuverable, the very uneven terrain provided occasional challenges. To bridge a gulley or stream, wooden trestles, such as the ones pictured here, were constructed to bridge the gaps. Construction had to be strong enough to hold the train and load, but was not expected to remain in use for more than a few years.

El Dorado Lumber Company solved the market transportation problem by building a cableway, unique in West Coast logging. Southern Pacific Railroad was in operation on the south side of the American River gorge; the big trees waited for harvest on the north. A cableway, strung 2,600 feet across the river canyon, was completed by July 1901 and hung 1,200 feet above the riverbed of the South Fork. The north terminal was at the top of the old log chute; the south connected to a narrow-gauge railroad leading to a Southern Pacific Railroad spur. The first cable cars were four-wheel carts with 7-foot wheelbases, but they proved unstable, dumping occasional loads into the river below, and were scaled back to much shorter wheelbases. The cable hauled cut lumber from Pino Grande Mill to the south, supplies to the north, and occasionally people in both directions. The cable remained in use until 1949. (Courtesy Michigan-California Lumber Company.)

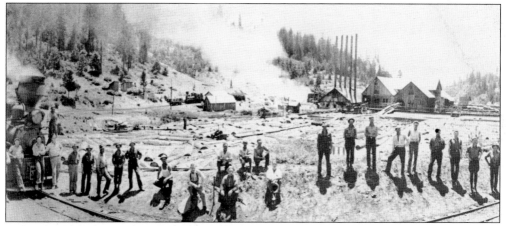

Pino Grande Mill was the largest mill in El Dorado County during its operation from 1900 until it permanently closed in 1951, when a new mill was constructed across the canyon. Motorized transport by truck made the outdated mill railroad and cable transfer unnecessary. In the photograph at right an empty log train is returning to the woods to be reloaded. The small white car directly behind the engine is a "Mulligan" car, a specially built refrigerator car well insulated against the hot California sun, used to bring perishable goods into the woods, usually supplying the logging camp cooks. As the community of Pino Grande built up, these cars were especially welcome, delivering fresh produce and meat to the families living at the mill. (Both courtesy Michigan-California Lumber Company.)

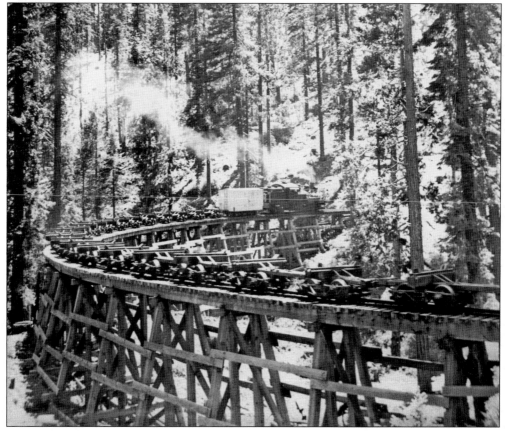

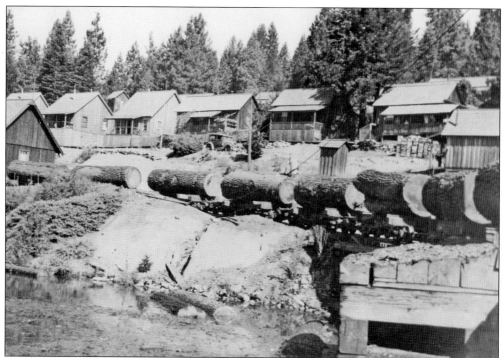

Pictured is a train of one-log loads ("big sticks") coming into the Pino Grande Mill. Cars were 26 feet long, loaded with 16-foot logs, and contained about 3,000 board feet of lumber. Between 10 and 20 cars made up a train that would go into the mill for processing. Daily train orders ensured the empties were dragged to where they could be loaded, and loaded cars would arrive at the mill in a timely fashion. (Courtesy Michigan-California Lumber Company.)

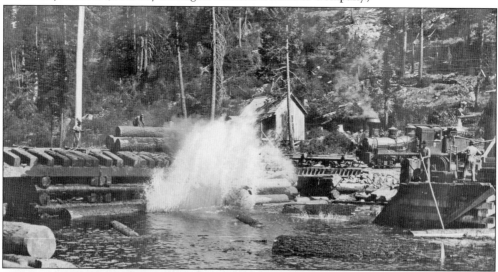

As logs would enter a mill, the entire train would be pulled alongside the pond. A "brow log" was fastened beside the track to keep logs from hitting the track or cars as they were rolled off. Once into the pond, logs were pulled by a log chain onto the log deck for processing, first being pressure washed, then put into a high-speed band saw to slice it into boards. (Courtesy Michigan-California Lumber Company.)

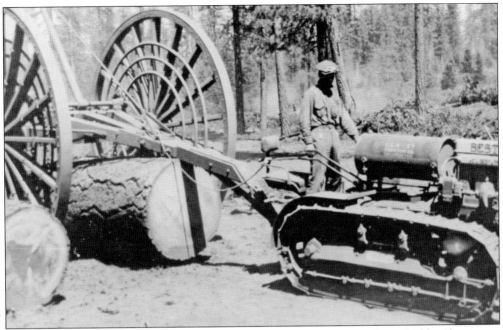

The introduction of the internal combustion engine to logging proved invaluable. Shown is a big wheel arch being pulled by an early Best-brand tractor. One end of a log was pulled up into the arch between two wheels so that as the tractor was pulling the log along, the front end was lifted off the ground. The arch was first used with horses, which provided the pulling power, but the tractor pulled much greater weights. The introduction of trucks represented the most significant change in the logging industry's emphasis on mobility. Trucks can get much closer to where the timber is being felled and offers mill options. Pictured is a 1930s dump truck adding a load to a section of Wentworth Springs Road that will be used for a hauling road. (Both courtesy Michigan-California Lumber Company.)

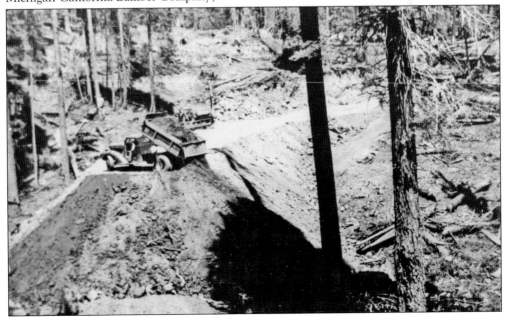

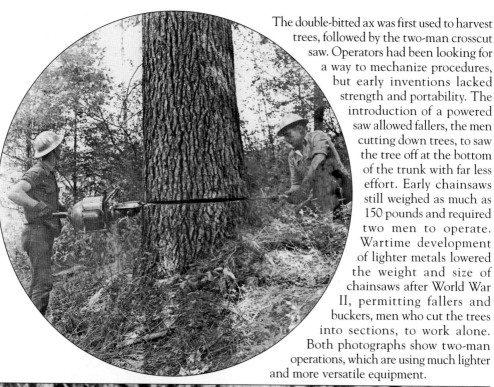

The double-bitted ax was first used to harvest trees, followed by the two-man crosscut saw. Operators had been looking for a way to mechanize procedures, but early inventions lacked strength and portability. The introduction of a powered saw allowed fallers, the men cutting down trees, to saw the tree off at the bottom of the trunk with far less effort. Early chainsaws still weighed as much as 150 pounds and required two men to operate. Wartime development of lighter metals lowered the weight and size of chainsaws after World War II, permitting fallers and buckers, men who cut the trees into sections, to work alone. Both photographs show two-man operations, which are using much lighter and more versatile equipment.

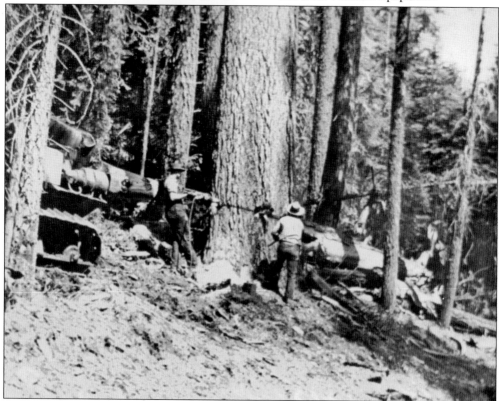

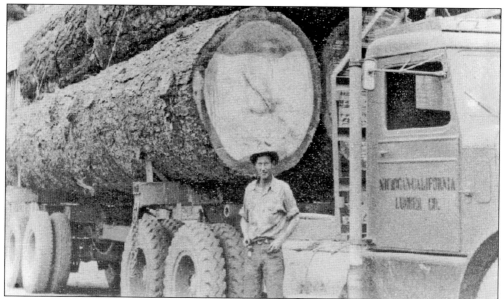

El Dorado Lumber Company did not survive a financial panic in 1907, but C. D. Danaher Pine Company bought all the assets. Various members of the Danaher family operated the company until January 1918, when Michigan lumberman John Blodgett merged holdings he had purchased on the Georgetown Divide with Danaher's, forming the Michigan-California Lumber Company. The new company continued to expand its holdings and continued to prosper, with the Pino Grande Mill running at full speed. Although it was booming, by the mid-1940s Pino Grande equipment was beginning to wear out or was becoming obsolete. Trucks were hauling logs farther each season, and a fire at the cable tower in March 1949 forced a decision. Pino Grande ceased operations in 1951, and all mill structures were razed. (Both courtesy Michigan-California Lumber Company.)

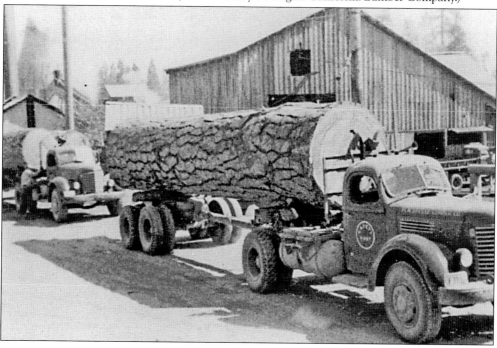

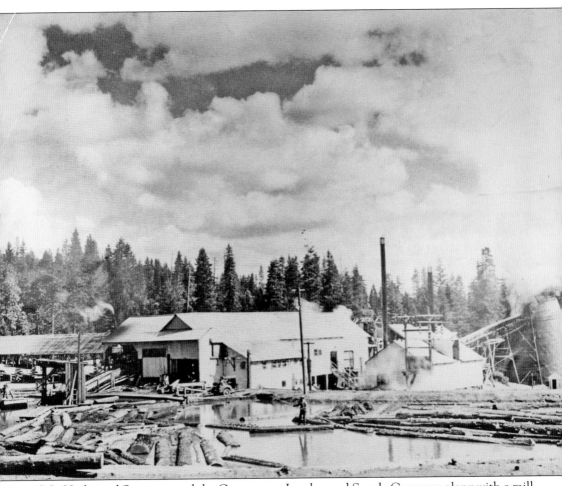

J. L. Hosler and Sons operated the Georgetown Lumber and Supply Company along with a mill east of town from approximately 1914 until the mill burned in June 1920. Reconstruction started right away, but the company folded almost immediately. Georgetown Lumber Company was formed in 1941 by E. J. and Fannie Farrari and started timber operations on a fairly small scale, but their mill, pictured here at the peak of operation, quickly worked up to 25,000 board feet of lumber a day and employed over 75 people. The mill was the largest on the Georgetown Divide after Pino Grande was shut down. Georgetown Lumber and Supply Company ceased operations in 1961. Several other smaller sawmills, such as George Wylie's El Dorado Logging Company and Mel Crail's Mill, continued to operate for a few more years. By 1970, there were no longer any active sawmills near Georgetown. Timber harvesting continues, but all the logs are taken to mills off the Georgetown Divide.

Eight

BOOMS, BUSTS, AND BACKWATER

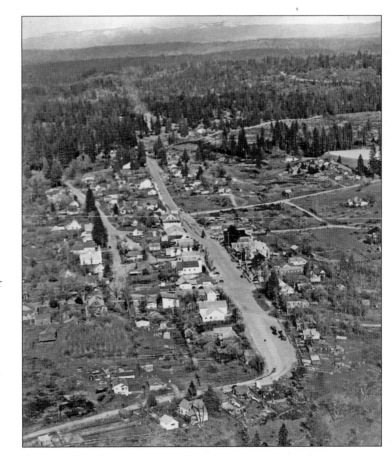

This is a rare aerial photograph of the town site of Georgetown, taken around 1950 by self-proclaimed Georgetown publicist and promoter Walter Drysdale. The bare patch (upper right) is the cleared hill for the Georgetown School. Smoke (upper center) is rising from Crail's Sawmill. The large white structure (lower center) is the newly constructed Georgetown Masonic Lodge, built to replace the lodge that burned in July 1948. (Photograph by Walt Drysdale.)

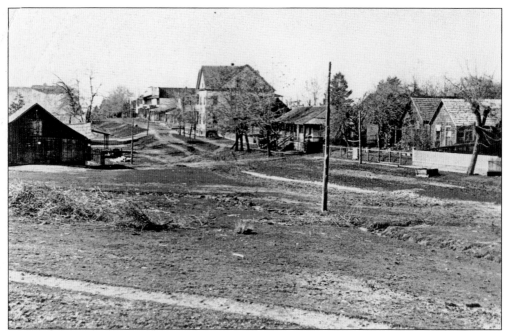

A short spurt of activity occurred around 1900 when an ambitious plan to open many of the old mines was formulated. This panoramic photograph was taken from the site of the current Woodside Mine Park, looking south down Main Street. The American Hotel, rebuilt after a fire in 1899, is in the center of the photograph.

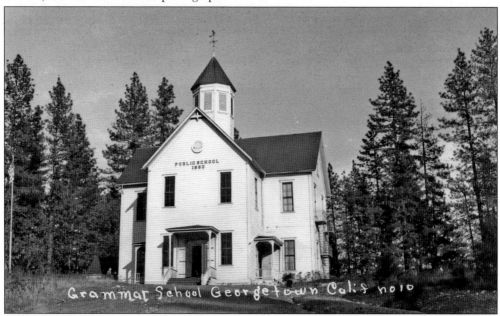

By the mid–20th century, Georgetown School, built in 1890, was beginning to deteriorate and merited replacement. The upper story had not been used for several years, since high school students were sent to a building on Church Street in 1922. The old structure was torn down, and the hilltop bulldozed to make extra room. Current Georgetown Elementary School buildings were constructed on the same site.

A stage stop known as Balderston Station, pictured around 1920, was one of the many places where food and rest were available to travelers along the Georgetown Divide. Located at the intersection of Wentworth Springs Road and the east end of Balderston Road, when automotive travel was introduced, Balderston Station became a bar and store, first in the structure at left, then moving to the house. Patrons had to walk across a wooden bridge over the ditch to reach outhouses. The buildings were all pulled down in the late 1960s.

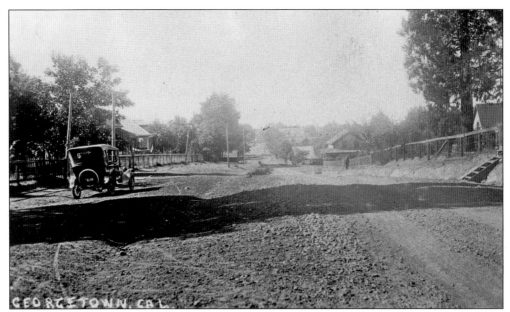

Following a burst of activity when local mines reopened in 1916, the subsequent shut down and loss of manpower to the war depleted local economic forces. One by one, old business establishments shut down. By 1928, there were only three small grocery stores open, with a shoemaker, barbershop, stationery store and post office, and auto garage and repair shop comprising the business district.

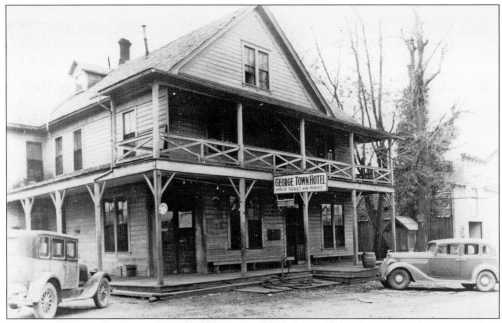

The landmark Georgetown Hotel changed ownership a number of times after popular owner-builder Carlos Forni died in 1905. A. J. Macey operated the hotel for a while, then sold to Elizabeth McPherson of Placerville. McPherson leased the hotel to Walter Reinhardt who remained only a few years. The hotel did not become a successful operation again until the mines reopened in the early 1930s.

After reopening for business following a fire in 1899, the owner of the American Hotel, Mary Bundshuh, died the following year. Her son George Heuser Jr. continued to operate the hotel on the side for a few years then sold to A. J. Macey. The hotel was converted into a tuberculosis sanitorium in 1916. It sold again in 1920 to the local Farm Bureau and Community Club. The photograph above was taken in 1933, just before Mr. and Mrs. Charles Wood acquired the property and once more opened it as a hotel—the Woods Hotel. They sold to Herman Asbill in May 1935. Eventually the building became the private residence of Robert McGowan until it was purchased by Marion and Alfred Podesta and Marge Whitelaw around 1970. The structure was remodeled and renamed the American River Inn, now a bed-and-breakfast.

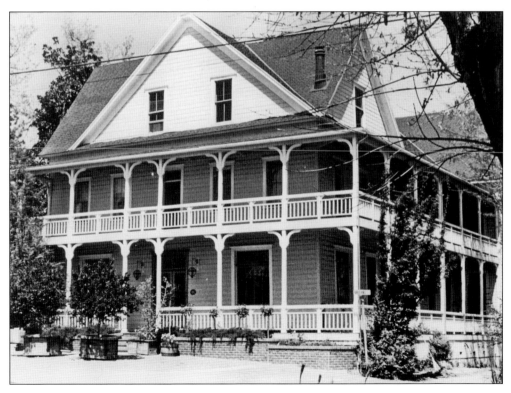

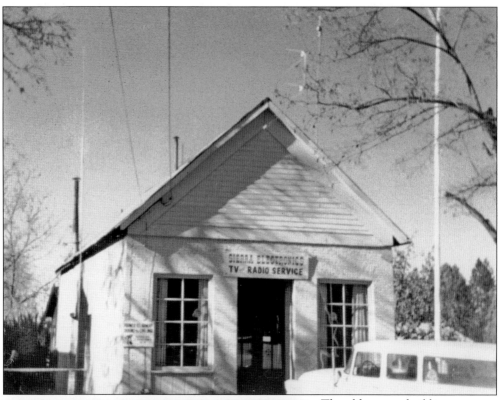

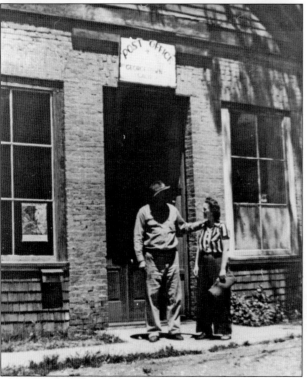

The old armory building, constructed for the Civil War, has served several purposes. Damaged in the 1869 fire, it remained vacant for several years. It was remodeled to serve as a church by St. James parish in 1881 and served as the chapel and priest's residence and study until 1923. The telephone company was located here until the 1934 fire, then moved next door. The structure was empty again until taken over by the postal department. Postmistress Lempi Kivi-Aho and her husband briefly lived in the rear of the building before turning it into a town library; Lempi served as both postmistress and librarian. In 1957, the post office moved out and the structure hosted a number of tenants, finally being converted to a coffee shop.

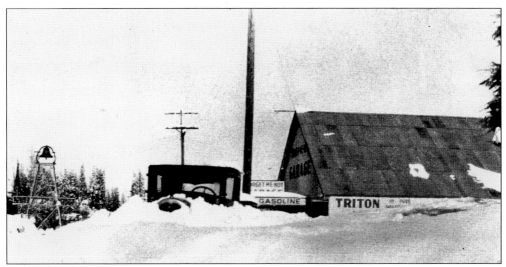

Clarence S. Collins, grandson of Georgetown pioneers Samuel and Dove Melissa Collins, opened the first full-fledged auto mechanic's shop in Georgetown in 1921, remodeling the old Orelli livery stable. The Forget-Me-Not Garage, on the far right of the 1938 photograph above, was damaged in 1934 when flaming debris from the conflagration across the street floated across. Collins acquired the Studebaker auto agency in Placerville and closed the garage in 1942. The building was rented to Pacific Gas and Electric during the war years. Clarence's son Ken, pictured below with Keith Raty working on a mail truck, reopened the garage. Vern Hendershot took over the building and garage business in 1950, selling out to Harold and Mike Murchie in 1966. Murchie's Garage was a mainstay of Georgetown for 40 years before changing hands to become an auto parts store.

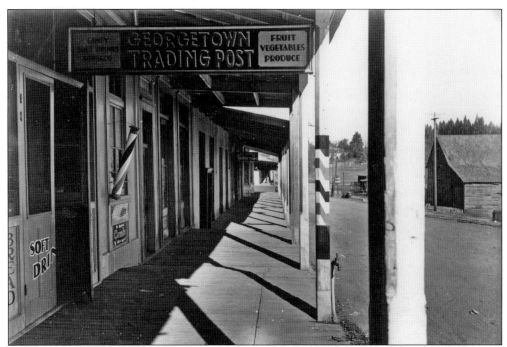

While the rest of the nation suffered from the Depression, Georgetown suddenly thrived. The arrival of electricity in 1928 added to readily available cheap manpower, and the gold mines in the area were booming again. The Beebe-Eureka, Alpine, Clark, and Swift-Gold Ledge mines were the first to open in 1932, their payrolls significantly boosting local economy. Storefronts were reoccupied, the newspaper saw print again, and Georgetown economy was healthy once again. The surge slackened when a fire in 1934 charred the middle of the business block. This time the rebuild took over two years. An extensive county road oiling program coincided with the overhaul, changing the appearance of Georgetown again. These photographs of Main Street, looking northward, were taken around 1930–1931, just before the mines began to open.

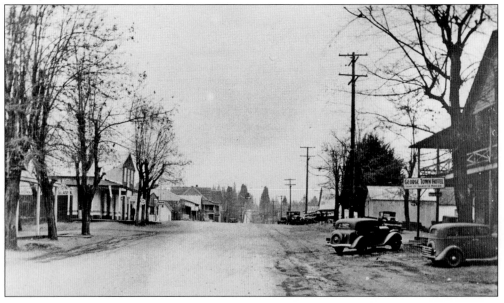

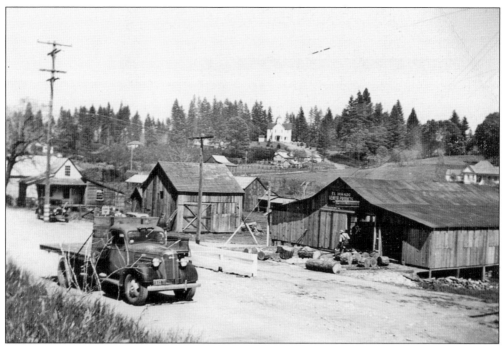

T. H. Brumis of Placerville purchased the lot next to the Forget-Me-Not Garage in 1943 and started construction of a veneer and box plant to take advantage of the growing popularity of fruit coming from the Northside district orchards surrounding Cool. Georgetown Express hauled the finished products out and brought "shook" (slim, flexible boards used over fruit boxes) back. The business closed within 18 months, and Brumis relocated operations to Placerville. The empty structure was rented to the newly incorporated Georgetown Divide Public Utility District (GDPUD) in 1945. When GDPUD built new quarters above Eureka Mine Plaza in 1977, private ownership bought the building, and no commercial business operates there. These photographs were taken at the height of operations in 1944.

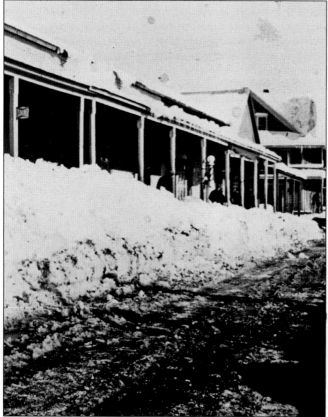

The long and extremely severe winter of 1937–1938 marked the beginning of yet another slow period in Georgetown history. After an initial boom, mining was beginning to slack off somewhat and ended abruptly in 1942 as the United States entered World War II. Men left for war or went to work for higher pay in defense industries, and business activity subsided. It was another bust for Georgetown, although this time the economy did not sink to the same depths it had been in before. Lumbering, which had been gradually building in importance, kept the latest recession from being as severe as previous ones. The main roads of Georgetown, including Main Street, were paved in the late 1930s, solving some of the transportation problems of the area.

A stone building had been constructed just after the 1856 fire by merchant Francis Graham for his general mercantile store at the corner of Main and Sacramento Streets, the third time he had recovered from a fire. Clarence Hotchkiss bought the building in 1893 and opened the Co-op Union Store. After his death, the building was empty until torn down in 1944. Charles Marshall built the stucco structure now standing there, first a market, then an auto parts store.

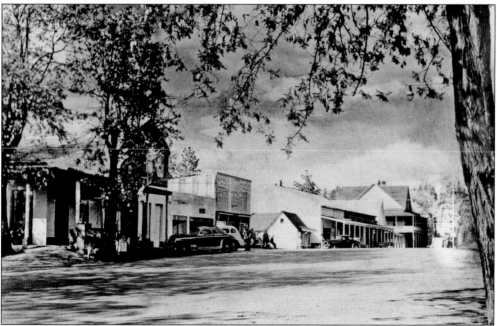

The eras of gold and lumber had passed by the mid-1950s. The town had settled into a sedate, stable community. Residents and businesspeople continued to come and go—but at a more even pace. The small frame building at center of this photograph taken about 1952 is Fannie's Beauty Nook. The building was torn down in 1962 for construction of the new firehouse.

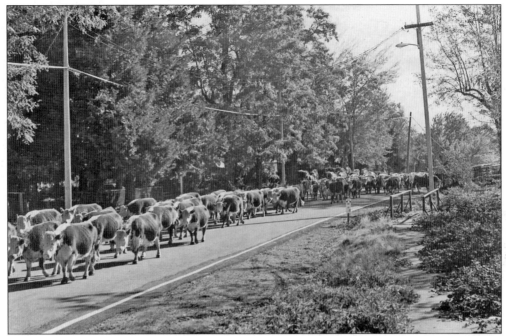

As one era ends, another begins. The cattle drive down Highway 193 in 1979 (above) was the final time cows were moved by horse and dog, ending a tradition that had been going on since Georgetown was founded—driving stock to higher, cooler pasture for the summer. They are now moved by motorized transport. Georgetown Airport (Roediger Field) was formally dedicated on May 27, 1962, with a fly-in breakfast. Built primarily with volunteer labor, equipment, and materials, the 3,200-foot runway (below) is a popular stopping place for instructors with student pilots. Rising terrain offers a challenge on one end, as a deep canyon on the opposite end offers its own challenge.

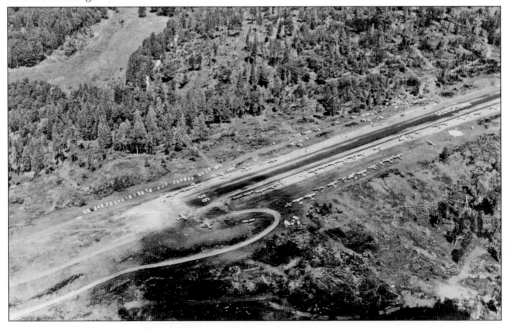

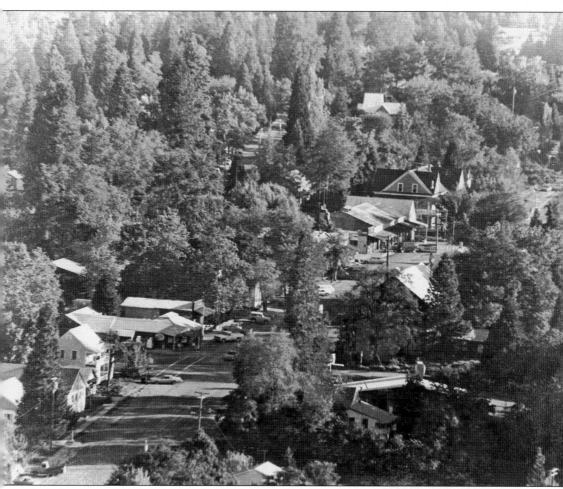

Seen from above at the intersection of Highway 193 and Main Street, 1976 Georgetown nestles among the trees. The character and composition of the town has undergone a subtle change from its beginnings. Fewer citizens can trace family lines back to the gold-mining days. More and more of the people moving in are looking to escape the city, many commuting back there to make a living. The business community has changed as well, relating to tourism and recreation. Commercial structures have expanded away from the main district, adding Growlersburg Shopping Center; Buffalo Hill Shopping Center, a business complex at Eaton Road; and several small commercial arrangements at Eureka Mine Plaza and along Highway 193. Recessions and escalations continue to go on and continue to affect Georgetown, but the commotion and excitement present in the beginning will never be felt again.

www.arcadiapublishing.com

Discover books about the town where you grew up, the cities where your friends and families live, the town where your parents met, or even that retirement spot you've been dreaming about. Our Web site provides history lovers with exclusive deals, advanced notification about new titles, e-mail alerts of author events, and much more.

MADE IN THE

Arcadia Publishing, the leading local history publisher in the United States, is committed to making history accessible and meaningful through publishing books that celebrate and preserve the heritage of America's people and places. Consistent with our mission to preserve history on a local level, this book was printed in South Carolina on American-made paper and manufactured entirely in the United States.

This book carries the accredited Forest Stewardship Council (FSC) label and is printed on 100 percent FSC-certified paper. Products carrying the FSC label are independently certified to assure consumers that they come from forests that are managed to meet the social, economic, and ecological needs of present and future generations.

FSC
Mixed Sources
Product group from well-managed
forests and other controlled sources

Cert no. SW-COC-001530
www.fsc.org
© 1996 Forest Stewardship Council

Find Your Place in History.